153
6

D0149034

# GIFTED AND TALENTED
# IN ART EDUCATION

- Stanley S. Madeja, Editor

National Art Education Association
1916 Association Drive, Reston, Virginia 22091

The Library
Saint Francis College
Fort Wayne, Indiana 46808

91-1202

Copyright 1983 by:
National Art Education Association
1916 Association Drive
Reston, Virginia 22091

04 • 1M • 783      ISBN 0-937652-00-8

# • C O N T E N T S •

Introduction: Stanley S. Madeja       5

**Section I: School and Community Programs**     9

The Artistically Talented in an Urban Community
    *Elaine L. Raichle*     10

Education Through Art and Historical Preservation
    *Lloyd L. Sensat, Jr.*     21

Options for the Artistically Talented
    *Lee Hanson*     32

Project Challenge
    *Susan E. Sutliff and Roxanna Smith*     39

CAPP: Creative Art and Printmaking Program
    *Ann Petrilla*     45

Extra-Ordinary Art Classes
    *Charlott Jones*     51

New York City's Music and Art High School
    *Sheila Stember*     59

Artistically Talented Program in the Jersey City Schools
    *Margaret Weber and Anthony S. Guadadrielo*     65

**Section II: State and National Programs**     73

The Indiana University Summer Arts Institute
    *Gilbert Clark and Enid Zimmerman*     74

Oklahoma's Unique Fine Arts Camp
    *Jane Nelson*     81

Seeking the Best: Georgia Governor's Honors Program, Visual Arts
    *Ruth Gassett*     88

Pennsylvania's Governor's School for the Arts
    *Clyde McGeary and Arthur Gatty*     93

The South Carolina Governor's School for the Arts
*Phillip C. Dunn and Thomas A. Hatfield*                     101

ARTS/The Program and the Process for Recognition
of the Gifted and Talented in the Arts
*Charles M. Dorn*                                            107

**Section III: Commentary**                                  115

Serving the Needs of the Gifted Through the Visual Arts
*Catherine A. Fritz*                                         116

What Happens after the Gifted Program?
*Jimmy S. Maine and Robert D. Clements*                      121

# Introduction

•STANLEY S. MADEJA•

The purpose of this publication is to review exemplary programs for gifted and talented students in art. The programs were identified by a national review process by which seventy-five were recommended for publication. Criteria used to select the programs included the following: programs which concentrated or had a strong instructional component in the visual arts; programs which had demonstrated, by recommendations or outside review, excellence in art content and instruction; and programs which could be generalizable to a national audience. The authors were asked to give an overview of the program, which includes goals, student population, location, and a narrative description of the teaching process and course content. They were also asked to include unique features of the program which make it exemplary and to describe the results of the program through case studies or follow-up surveys. Finally, a description of how the program is supported is included when applicable.

The publication is divided into three sections. Section One contains programs which are school and community-based. A number of school systems and communities offer opportunities for gifted students as part of their ongoing school programs or as an out-of-school program. The art programs reviewed are concerned with the gifted student from kindergarten through senior high school. The emphasis in each program varies, from the magnet school program of Irvington, New Jersey, for grades five through eight offering a range of art instruction, to a more limited focus of the printmaking program of Queens, New York. Lloyd Sensat's program in Education through Art for Historic Preservation contains unique and stimulating art content drawing directly on the architecture of the community as subject matter. The High School for Music and Art is a comprehensive pre-professional school for gifted students, in its forty-seventh year of operation. Thus, this section gives a cross section of examples of instructional approaches that are working in schools and communities and have stood the test of time with continued success.

Section Two contains gifted programs in art which have gained national recognition which serve a state and national audience. A number of states such as Pennsylvania, Georgia, and Oklahoma have initiated programs for talented students in the arts to receive in-depth instruction in the arts as an extension of the school programs. One of the oldest of these programs is in Pennsylvania and is a model which a number of states have followed. The program is supported in part by state funds and is sponsored by the State Department of Education with endorsement and support from the governor of the state. A national program to accomplish similar goals is described by

Charles M. Dorn, and although in its beginning stages, the program shows promise of providing a national platform for recognition and development of gifted students in the visual arts.

The last section contains two articles which are commentaries on two aspects of the gifted program. Catherine Fritz relates how the art program for the gifted can serve a population talented in art but also be extended to the student who is gifted in other areas of study. In addition, she describes programs in schools that exemplify this idea. A fitting concluding article by Jimmy Maine and Robert Clements describes what happens to the student after the gifted program.

Art education has been as involved with artistic talent in the visual arts in many contexts. These associations have had a positive and sometimes negative effect on the connotation of what the art program is in our schools. The general education goals for most art programs have been eroded in some instances by the idea that one who takes an art course must have to be gifted or talented in drawing or design. How many times has the cliché of "I can't draw a straight line" been used as an excuse for not taking an art course in high school or college. Because of this, the general public may view the art program as something special or unique and not a part of the general curriculum. In a positive context, the public has the view that the visual arts and visual artists are contributing to our society as a whole; they do not negate the importance of art as a part of our cultural heritage and development. For the most part, people value art and its contributions to our society but do not associate that with becoming educated in and about art. The recent resurgence of interest in programs for the gifted and talented has aided in clarifying the role art educators have in the identifying, nurturing, and educating of the gifted and talented in art. The development of programs for the gifted in art has assisted art educators in defining the similarities, but more important, the differences between gifted programs and the general art program. The variances which exist in art content, instructional activities, outcomes for the students, and the teaching process become points of clarification between the two programs, thus giving our audience, the general public, a better understanding of both programs. Some of the characteristics of the gifted programs described in this publication indicate how these differences are being clarified.

In general, most gifted and talented programs in art—especially at the secondary level—require entry criteria for admission to the program. Among the requirements for admittance are performance art tasks in drawing or design, slides or a portfolio of the student's work, a written statement by the students about the visual arts and/or personal recommendations by artists and teachers. Some programs also use performance on standardized tests of general intellectual abilities as part of the entry requirements. By defining as a part of the entry requirement high level studio skills, the programs are not selecting the student who may have an intellectual interest in art for his or her own educational development; rather, they are interested in students who are artistically talented in studio skills. For the most part, the gifted

6

programs in art have concentrated on the making of art as the primary instructional activity, and little instructional time is devoted to formal art criticism or art history. Thus the gifted program in art is similar in content to the general program; that is, a heavy studio orientation, allowing for intensive and in-depth experiences in one or more of the studio areas, but tending to exclude students who do not excel in this area.

Another characteristic of the gifted and talented programs is that of creating a stimulating and creative milieu in which the student obtains instruction. The environment which most gifted programs provide for the student is different from what they experience in a regular art program, as they may spend all day for a number of weeks in a studio area, in a sense "living their art form." This intensity and constant exposure provides them with a different perspective of the visual arts as a discipline; consequently, they experience first hand the commitment one must make to excel as an artist or designer.

Finally, a number of gifted and talented programs have a base in the community or at the state level for support and instruction which is a broader base than that of most school programs. The support comes from public agencies such as State Departments of Education or State Arts Council, but programs also are able to secure monies and services from foundations and corporations. This gives them a broad base of support and outreach which goes beyond traditional means of supporting educational enterprises.

Why at this time in our educational history, when schools face some of their most difficult challenges in this century, are there now programs for the gifted emerging? A number of factors have contributed to the return to quality-based educational systems which serve a varied population and produce a cultured and literate graduate. There is no doubt that the national concern for providing a basic education for each student has had the effect of promoting gifted and talented programs. The schools are facing significant public pressure to graduate students who have functional reading and computation skills. Within this climate in the schools, it is less difficult to convince the public that the gifted and talented student needs special programs to meet his or her needs. It has become evident that school systems, singly or in cooperation with other agencies, can be a significant contributor to the education of a gifted student if given the resources and talent to fulfill this goal.

A major factor that has contributed to the development and creation of gifted programs in the arts has been the emergence of magnet schools predominately in urban areas. The rationale for the "magnet idea" was developed because the schools were under pressure from the federal government to integrate, and thus began the identification of schools which had a special emphasis in a subject area or developed unique skills. A number of magnet schools are centered in the arts. Not all magnet schools are limited to gifted students, but because of this organizational scheme, many of these schools have started gifted programs. Another factor which has stimulated the creation of gifted programs is the desire by arts agencies and colleges to extend the formal art education experience beyond the normal school day

7

and year. In some instances, as in the State of Oklahoma, the program was developed to provide educational experiences in the arts which schools did not or could not offer, such as ballet, mime, serigraphy. The gifted program in art, in this case, becomes an extension and expansion of the school based program. Still the most compelling reason for this resurgence of gifted programs in the arts has been the desire on the part of art educators and community arts leaders to provide a quality art experience for the talented student. It has become evident to those of us in education that our most valuable national resource resides in our talented students wherever they exist. Communities realize that the school system should and must provide substantially rich and challenging programs for these students. Many art educators, as exemplified in the program in this publication, have accepted this challenge and designed programs to meet the gifted student's needs.

<div align="right">S.S.M.</div>

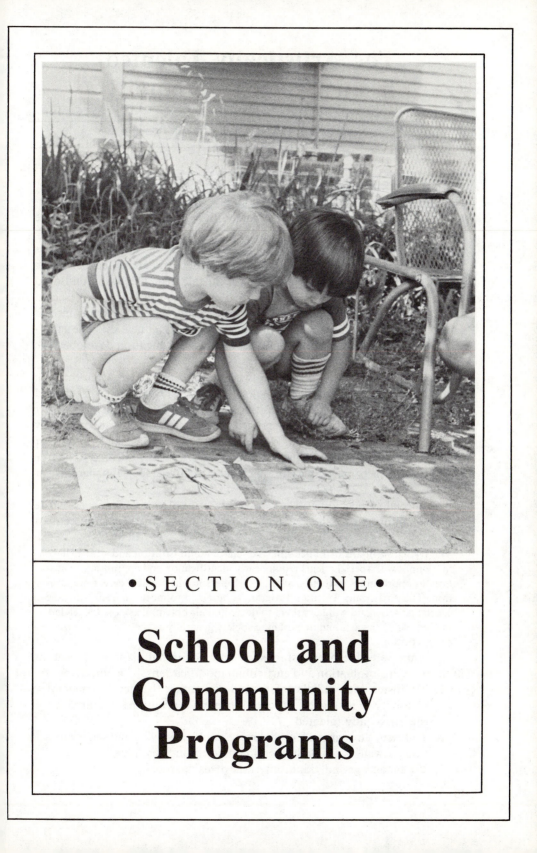

# School and Community Programs

# The Artistically Talented in an Urban Community

## • BY ELAINE L. RAICHLE •

In 1977 a special program for the artistically talented began in Irvington, New Jersey. The town of Irvington, a highly urban, largely blue-collar community, has a population of approximately 70,000. School enrollment is more than 85% minority.

A federal grant under the Emergency School Aid Act (ESAA) gave funds for equipment, supplies, an additional art teacher, and an art teacher's aide for the proposed arts education classes for the talented. The Irvington Board of Education provided for the hiring of a music teacher from its own resources. With funding for major items no longer an issue, plans moved ahead for the special townwide program in career arts education. The supervisor of art education and the supervisor of music education developed the program and administered it.

Union Avenue School, a building with children in kindergarten through grade eight, was selected as the magnet school. The Artistically Talented classes were programmed for grades five through eight. The principal, Walter Rusak, an enthusiast for the new program, had the flexibility and ingenuity that permitted it to flourish. He developed a schedule that blocked time for the arts classes in a student's day, allowing the artistically talented to be free at the same time to participate in rehearsals, to attend special programs, or to take trips.

The special subject supervisors, in cooperation with arts teachers, wrote the philosophy, goals and curriculum. To quote from their statement of philosophy:

> The Irvington Board of Education, the school administration and staff believe that pupils with special talents require early identification and appropriate educational opportunities in their growth, development and possible career preparation. The Artistically Talented Program is designed to meet the needs of these special children and will help them to develop their potential as possible leaders in the field of the arts and in enriching society generally as they become citizens of the future.

Program objectives were established both for initial planning as well as in the on-going evaluation and curriculum modifications. The objectives are:

1. To foster each child's talent and encourage the development of creativity to its highest potential through a program structured for the artistically talented.
2. To teach, through student discovery, problem solving and self evaluation as well as through experimentation and research.
3. To encourage individual interests of each student.

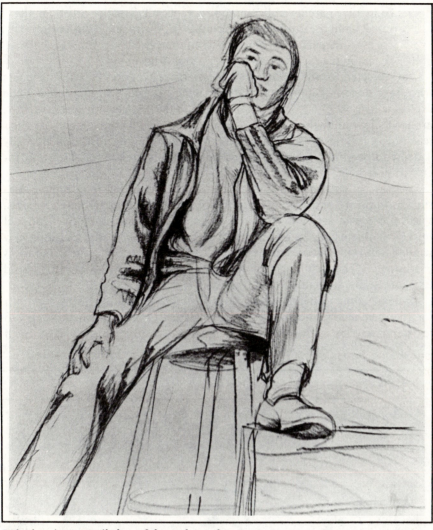

*Life drawing, pencil, by a 9th grade student.*

4. To develop the skills necessary for success in the area of talent.
5. To develop a wide-ranging program in related arts and multi-media components dealing with common elements and unique possibilities in the arts.
6. To provide for student growth in ability to judge and improve the quality of an artistic product.
7. To develop a student's aesthetic sensitivity and response to emotional values and cognitive meanings in the arts.
8. To encourage articulation by students of feelings, moods, problems and successes, verbally, in written form, and in artistic expressions.

9. To involve parents and community, especially creative artists, in the process and the product of the classes for the talented with exhibits, workshops, performances, and conferences.
10. To maintain racial balance within our student body.

Staff selected for the innovative education are experienced artist/teachers who have demonstrated the ability to create programs of substance while exploring new ways of teaching. In addition to the permanently assigned staff, art teachers within the school system have been relieved of part of their teaching schedules to add their expertise and training to the Artistically Talented Program. Several professional artists are invited for short residencies to enrich the offerings.

Selection of students for the program is of paramount importance. Arts staff, in cooperation with the administration of each of the Irvington Schools, select those who are to participate. To make their decisions, they conduct tests, examine examples of art work, study student records, and interview students and their homeroom teachers. Self-nomination to the program is encouraged. The final decision as to the enrollment, however, is reserved to parents and students themselves.

Students come to the magnet school from all sections of Irvington, both for the elementary and the secondary classes. Originally, there were 120 registered into six sections of art and music, grades five through eight. Each

*Still-life in India ink wash, by a 9th grade student.*

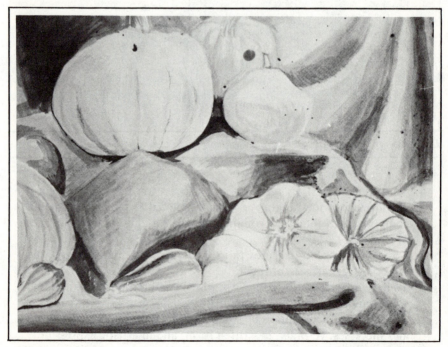

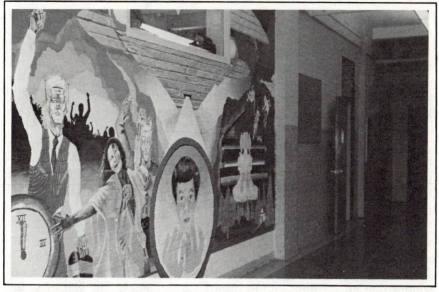
*Mural in acrylic by 8th grade students.*

child attends the magnet school the entire day with academic as well as arts subjects included in the schedule. In planning a student's day, art and music are scheduled first, and academic subjects are arranged so as to avoid interference with special education in the arts. Artistically talented classes work double periods of 90 minutes daily, as well as in special club time, for a total of more than eight hours a week.

Responsibility for transportation to the magnet school lies with the student and his parents. Since the community is compacted within a three-square-mile area, this creates fewer problems than one would think. However, it is true that some talented children must wait until seventh or eighth grade to enroll, since working parents cannot drive them and object to the long walk that attendance at a school located at the other side of the community will entail.

The developmental curriculum begins with in-depth instruction in art and music and also includes interrelated opportunities in theatre, dance, creative writing, video, and photography. Fortunately for the program, Irvington is within the metropolitan area of New York City, one of the richest art centers in the world. However, most of the children are unable to avail themselves of the nearby artistic resources unless the schools open up the possibilities. For thirty years, the Irvington schools have programmed professional visual and performing arts experiences in classroom and assembly programs, presented as part of the school curriculum. The Artistically Talented Program curriculum aims at intensifying and extending these.

The assembly programs give varied opportunities for appreciation, as visiting companies of artists in opera, mime, modern and ethnic dance and

ballet, musical theatre, and vocal and instrumental music visit the school. These cultural experiences are paid for by the Irvington Board of Education and sponsored for all Irvington students.

The present year's schedule of performing arts assemblies include "Jazz Impact," an instrumental group tracing the history of jazz; "Jim Thorpe, All American;" "First Lady," musical theatre about Eleanor Roosevelt; "Magical Imagination," theatre presentation of the life and times of Emily Dickinson; and "Taming of the Shrew," a ninety-minute production with a cast of twenty actors.

As an extension of these programs, there are additional workshops with the performing artists for the artistically talented students. A student participation workshop about acting, make-up, and costuming will be taught this year by the McCarter Theatre of Princeton for the artistically talented students.

Another stimulant to creative thinking and production is the artist who enters the classroom for a day. When students are working in water color, part of their education is the visit of W. Carl Burger (an art professor at Kean College of New Jersey and a well known painter) to the class to demonstrate his methods and to inspire student work. The best of sound filmstrips and motion pictures cannot match the living experience of observing an artist at work and interchanging ideas with someone who is recognized and successful in the field.

Students show their growth mentally, emotionally, and intellectually as well as artistically as a result of these experiences. Their school performances often directly reflect results of trips and assembly programs. Sometimes an ability to articulate ideas or evaluate an experience reveals itself in academic subjects outside the special program. Within the program, innovation and different approaches to staging, lighting, scenery, display techniques, and costuming, as well as in visual art products, show insight that students have gained from observing professionals at work.

Students produced a ballet and musical theatre of note this past year directly influenced by professional theatre: "The Nutcracker" and "H.M.S. Pinafore;" the first aided by workshops with the Westminister Dance Company, and the second by attending the Broadway production of "Pirates of Penzance." The two school programs were staged and costumed, acted, sung, and danced by students, guided by teachers of the Artistically Talented Program, with help from their parents and homemaking department of the school. Performances of each of the plays were given for children of the community, parents, and on a week-end, for shoppers in a nearby shopping mall.

Once a year, students publish a newsletter which describes and illustrates the many activities of the artistically talented, giving those in the program a record of their experiences and providing public relations for the program.

The art classes themselves involve children in a studio environment emphasizing individual interests and aptitudes. Each art room includes interest centers such as a library and a painting, ceramic, or printmaking area which facilitates individual instruction. A well equipped art room permits instruc-

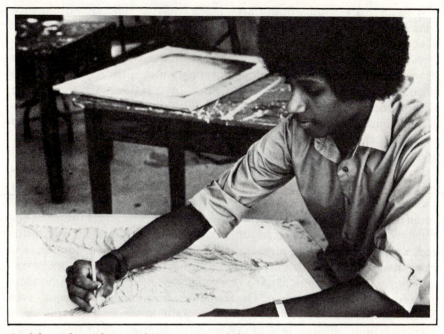

*An 8th grade student working on a pencil drawing.*

tion in painting, sculpture, film, crafts, architecture, printmaking, home planning, commercial art, and other art experiences. Students plan many of their individual projects with the teacher and learn to evaluate their own and others' work. Sometimes they work singly; sometimes they develop projects in groups to produce units such as puppet shows, for which they write the script, make puppets, design the stage and lighting, and direct the play. Performances are often presented for other children in elementary classes.

Visual arts students keep sketch books, an important tool for learning to observe and record impressions and a resource of ideas for drawings, paintings, or sculpture. Exhibits of their work are arranged within the magnet school, at local banks, libraries, New Jersey colleges, the Newark Airport, and the Educational Improvement Center (NJSDE) in a neighboring community.

The music program emphasizes music for personal development as well as performance. Children are stimulated to listen, to read, and to think about music in order to understand what they hear and perform. Students create original compositions; develop rhythmic perception through TAP machine; improvise accompaniments using autoharp, piano, and tone bells; and take part in musical dance and dramatic performances, many of which they write, direct, and choreograph under the supervision of the artistically talented music teachers. Workshops with professional artists and trips to cultural events expand the music students' horizon as they do in the visual arts and help to inspire and build a foundation for realistic career planning.

15

With successive grants from ESAA and a five-year validation of the program by the federal government, the Irvington school board has increased its support, and the program has moved, each of the last three years, to include an added higher grade. Thus, additional art and music teachers have joined the Irvington arts staff to provide continuing artistic growth for the talented students' progress through school. In 1981-1982, the tenth grade was included, with double periods in artistically talented classes in the Irvington High School. This year the Artistically Talented Program moves into grade eleven, and in 1983-1984 the program will be offering career education in the arts for students through grade twelve.

The cost of the program is small when compared with the benefits. Beginning in fifth grade in Irvington, all students take art and music 100 minutes a week from a certified arts teacher. This continues through grade eight. In elementary school the Artistically Talented Program provides four times as much working time in the classroom in the special area of talent than a student would receive in the regular school program. In high school there is more than twice as much time provided through double periods and extra activity. Cost is approximately $558 per pupil above the $1745 per pupil allotment for all Irvington children. The Irvington performing arts assembly cost is $2.00 per student. For value received, the amount spent on the artistically talented is nominal considering the impact on the lives of our future artists and citizens.

What do students think of the worth of the program? The following description by a ninth grade boy who was one of the first to enter the program reinforces our belief in how we educate the gifted. He writes of his experiences,

I have been in the magnet program for the last five years. In the fourth grade, I was introduced to the program, I was skeptical at first but finally decided to take part in the class.

From then on it's been one learning experience after another. My interest in the arts have grown tremendously, more than they ever would have in a regular class. I've learned that art is much more than drawing. It is the artist's way of expressing his thoughts and feelings. The extra time in art class has helped me learn self-discipline in working and teaches me to develop and use creative ideas.

And the field trips to cultural places and events like the Metropolitan Museum of Art, Metropolitan Opera, and Museum of Natural History have shown me the importance of art in today's world.

In the Artistically Talented Program there is a bond between student and teacher that otherwise doesn't exist. Talented students can work with other students at their own artistic level and learn from each other.

I plan to further my education after high school, majoring in illustration. Whatever becomes of my career as an artist, the Art Magnet Program has played an important part in my educational and artistic outlook.

*Tracey DeVaughn*

After five years of successful operation, the artistically talented staff of art and music teachers has grown from two arts teachers to three full-time

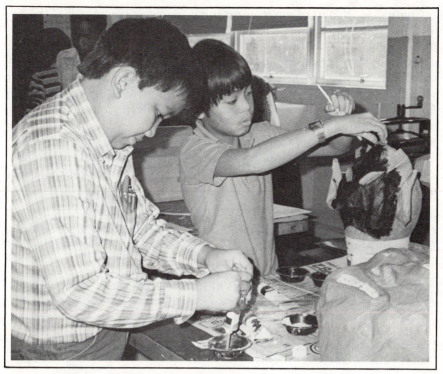

*7th grade students painting papier-maché masks.*

and two part-time teachers and one art aide. The aide, a graduate of School of Visual Arts of New York City and a free lance artist, works at elementary and secondary levels and brings an added dimension to the instruction. Five classrooms are now used as well as the "green room," a hall area adjoining the music room at the elementary school where small groups rehearse theatre and music productions. Auditoriums, too, are used as extensions of the classroom.

The growth of the students socially as well as artistically has been pronounced and is the test as well as the pride of our accomplishments. Teachers and administrators are persuaded that general abilities improve along with artistic development, probably in large part because of the recognition and support of a child's talent. This is not merely an impression. The schools use several evaluation forms of student accomplishments. One particularly has importance for our schools and possible others across the country. The art department has developed a tracking form to record student growth in leadership, attitudes, work habits, interests, academic achievement, abstract thinking and reasoning, as well as in creativity. Through testing programs and anecdotal records, the schools hope to document the value of early identification of talent and the part played by concentrated imaginative, enriched education in its development.

Continuing support of government funds has made the growth of the Artistically Talented Program financially possible. Federal monies provide approximately half the cost at the present time. Curriculum development, cooperation of other art and music teachers in the schools, creative and conscientious teaching by the staff, strong support by principals and central school administration, and the interest and commitment by the Irvington Board of Education have combined to offer to Irvington children truly unusual opportunities. The program has already proved itself. Its success has won widened support for the arts in both the schools and community.

Current plans by the administration include an enlarged program to provide for an increase in the number of children who can participate. Our limits now are only financial.

*Elaine L. Raichle is Supervisor of Art Education, Irvington Public Schools, Irvington, New Jersey.*

## IRVINGTON PUBLIC SCHOOLS
Irvington, New Jersey 07111

ARTISTICALLY CULTURAL CALENDAR PROGRAM FOR 1982-1983

| Date | Classes | Activity | Grades |
|---|---|---|---|
| *10/1/82 | Art/Music | Assembly program, FIRST LADY<br>A musical play about Eleanor Roosevelt | 4-8 |
| 10/4/82 | Art/Music | Assembly program, MAGICAL IMAGINATION<br>Mime, masks, and acrobats | 4-8 |
| 10/13/82 | Art | Bronx Zoo, trip for observation and sketching | 4-8 |
| *10/19/82 | Art/Music | Assembly program, BELLE OF AMHERST<br>Play on Emily Dickinson | 9-11 |
| 10/18/82 | Art/Music | Week at Irvington's Outdoor Education Center | 6 |
| 10/29/82 | Art/Music | Workshop on stage makeup - visiting actor | 5-8 |
| 11/1/82 | Art/Music | McCarter Theatre Workshop<br>Acting, makeup, costumes | 9-11 |
| **11/1-8/82 | Art/Music | Assembly program, JUBILATION<br>Black dance company of modern dance | 5-11 |
| 12/2/82 | Art/Music | Christmas Carol, performance by Artistically Talented Students for school and community | 5-8 |
| 12/7/82 | Art/Music | CHRISTMAS CAROL, play at McCarter Theatre, Princeton | 5-11 |
| *12/8/82 | Art/Music | Assembly program, JIM THORPE<br>Musical play on American Indian athlete | 5-8 |
| 12/21/82 | Music | Concert by High School Artistically Talented Students | 9-11 |
| 12/22/82 | Music | Concert by Union Avenue School Artistically Talented Students | 5-8 |

18

| | | | |
|---|---|---|---|
| *1/4/83 | Art/Music | Assembly program, TAMING OF THE SHREW <br> Performance by Washington University Theatre Co. | 9-11 |
| *1/17/83 | Art/Music | Assembly program, FIRST LADY <br> Musical play about Eleanor Roosevelt | 9-11 |
| 1/10/83 | Music | Musical Play - Student Production | 5-6 |
| 1/27/83 | Music | Workshop at Montclair State College, Baroque Music | 7-8 |
| *2/1/83 | Art/Music | Assembly program, JAZZ IMPACT, elementary program | 5-8 |
| *2/4/83 | Art/Music | Assembly program, INTERCITY DANCE ENSEMBLE, high school students of Paterson, NJ | 9-11 |
| 2/9/83 | Art/Music | Opera, *La Boheme,* Metropolitan Opera, NYC | 7-11 |
| 2/17/83 | Art | Carl Burger, Artist in Residence, visits classroom | 5-11 |
| 3/83 | Art/Music | *Evita* - New York Production | 7-11 |
| 3/83 | Art/Music | *Annie* - New York Production | 5-6 |
| *3/14/83 | Art/Music | Assembly program - NEW JERSEY BALLET Introduction to Ballet | 5-8 |
| 3/21 to 4/14 | Art | Newark Airport Exhibit of Artistically Talented Art | 4-11 |
| *4/5/83 | Art/Music | Assembly program, JAZZ IMPACT, History of Jazz | 9-11 |
| 4/83 | Music | Dance workshop, Westminster Dance Company | 5-11 |
| 4/14/83 | Art | Trip to Whitney Museum of American Art, NYC | 9-11 |
| 4/83 | Art/Music | Newark Museum, Hispanic Exhibit | 5-8 |
| 5/83 | Art | Brooklyn Museum Trip, Brooklyn, NY | 5-8 |
| 5/83 | Music | High School Music Concert, Artistically Talented | 9-11 |
| 5/83 | Music | American Ballet Theatre, Lincoln Center, NYC | 5-11 |
| 5/11/83 | Art/Music | Teen Arts Festival, County Arts Festival, Rutgers University, Newark | 9-11 |
| 5/83 | Art/Music | Artistically Talented Ballet Performance for school and community | 5-8 |
| 5/26/83 | Art | Trip to Outdoor Education Center, Flemington drawing and photography | 9-11 |
| 6/83 | Music | Artistically Talented Music Recital | 5-11 |

*Starred items are Actor's Equity Performing Arts programs sponsored by Irvington Board of Education.
**JUBILATION is a professional dance program sponsored by the Irvington Cultural and Heritage Committee.

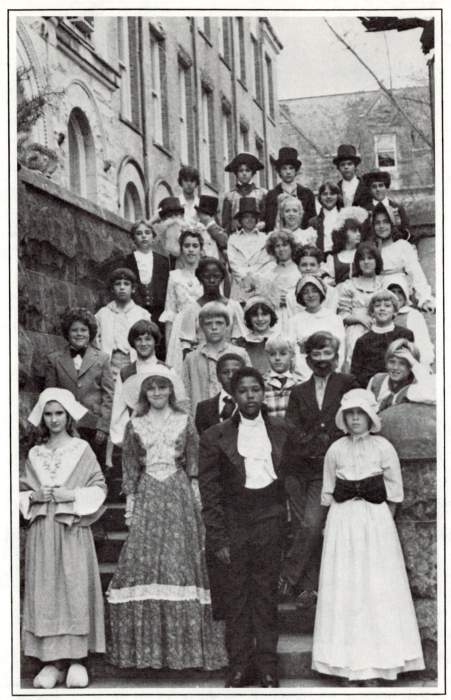

*Students at A.A. Songy Elementary School pose in their costumes of Creole/Cajun culture, at Tulane University School of Architecture.*

# Education Through Art and Historic Preservation

## • LLOYD L. SENSAT, JR. •

Every child needs a sense of place, a way to identify personally with our structures, neighborhoods, and communities of yesterday and today, as well as with the feelings and lifestyles of their inhabitants. The past can be used to help understand today and tomorrow. Children have to know about the how, why, and what of the built world in order to understand how it has worked to make them who they are. Buildings, our built environment, play a major role in our lifes: we work, play, and sleep in them. Yet architecture is an art form grossly neglected in most school art programs. In response to this concern, Lloyd Sensat developed and implemented an art program concerned with preservation of historically significant architecture and environmental awareness.

Excellent and effective programs are not carbon copies of a perfect mode. They are designed by teachers with a view to incorporate the particular strengths of a school and community. Mr. Sensat is the art specialist for the Resource Center for Students Talented in the Visual Arts at A. A. Songy, Sr. Elementary School and Lakewood Junior High School of the St. Charles Parish Public School system. Both schools are adjacent to each other in Luling, Louisiana, a small town on the West Bank of the Mississippi River not far from New Orleans. Although this area is still predominately rural, industrial progress has bulldozed most of the great 18th and 19th century plantations that once lined the River Road. Plantations are Louisiana's equivalent to the castles of Europe along the Rhine or Loire. Realizing this fact and the reality that these architecturally important structures had no future without the interest of young people, Sensat had his student artists interpret and document a local landmark each school year.

Dr. Eugene Cizek, a restoration architect and professor of architecture at Tulane University School of Architecture, agreed to be the project's architectural consultant. Dr. Cizek possesses a conviction that historical preservation and environmental awareness are integral issues which should be emphasized in schools. He, along with Mr. Sensat, decided that the interaction of elementary and college students would be an important aspect of the program and would provide both groups with a unique learning experience.

The Tulane architectural students serve as role models for Songy/Lakewood talented student artists. One Tulane student's comment is evidence of the benefit both groups derived from the experience; "I really enjoyed working with the elementary/junior high students . . . I hope they learned something from me. I know that I learned something from them, as far as talking with them, drawing with them, trying to help them."

Both teachers were serious about getting their students out of the classroom and to the various sites of study. Dr. Cizek describes his college students' reaction to the program: "When the Tulane students come together with the Songy/Lakewood students, there's a kind of magic that you just cannot plan, and somehow it all begins to mesh and out of it grows something very positive."

This feeling is reinforced by Songy's principal, Carolyn Woods: "The program has definitely had a positive impact on the self-concepts of the students involved. In each year's program there have always been a number of talented student artists who might have been categorized as educationally handicapped, or even, in some cases, behavior-disordered. These students, however, once involved in the program, definitely experience a more positive self image. Their teachers, their parents, and their peers have been astounded by the quality of their art work, their sophisticated drawings. Their having excelled artistically and having received recognition for it, I feel, has caused them to be motivated to try harder in all of their academic subjects."

This program also promotes an integration of the arts and the regular academic curriculum. Each school year the talented student artists have worked with either the academically gifted class, accelerated social studies class, the bilingual French program, or the dramatic arts class. From this integrated partnership comes the research, oral history interviews, title searches, role playing, and architectural documentation. Humanities teacher, Rita Carlson, expressed her feeling concerning the program: "My students were introduced to the idea that old can be important and that even though you are still very young, you can have relationships with things that are old, buildings, as well as people."

The continuity of the generations and the possibilities for their future allowed the humanities students to explore the past with their hands, minds, and emotions. Their writings capture many of their feelings as expressed by eleven year-old Kristen Carr's personification of "Homeplace Plantation:" "I've been here for a long time, and now I'm starting to feel old. As each day goes by, I feel a hundred years older; my structure is starting to collapse, and I'm afraid they don't have enough money to restore me. My major worry is that any minute now someone will come and destroy me. I enjoyed it when I lived in the past because then I was always happy; I never had to worry about being torn down because I was young. I'm sad now and will be until someone restores me. If you don't help me, I will fall because my structure is falling lower every second. In the future I hope to see all my dreams of happiness come true."

In the program the buildings themselves have also become teachers, and each landmark has provided a different lesson. In 1977-78 the students worked at "Homeplace Plantation," built in 1770 and considered to be one of the finest surviving examples of French colonial architecture in America. Part of the students' experience that year was working with 85-year-old Richard Keller, who was born and raised at "Homeplace." "Destrehan Manor," constructed by the same master builder as "Homeplace," became the focus for

the 1978-79 school year. As a public museum owned and managed by the River Road Historical Society, "Destrehan" did not have an old and wise Richard Keller as the living link to the past who helped the young students understand their place in the continuum of history. To compensate for this

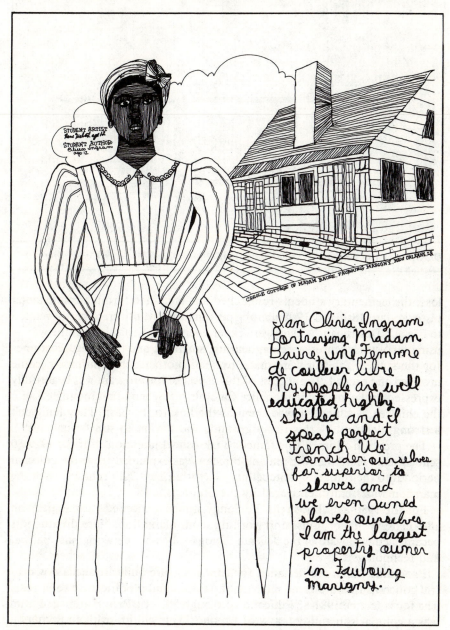

*Drawing of Madame Baure by Rene Hebert, age 12. Commentary by student Olivia Ingram.*

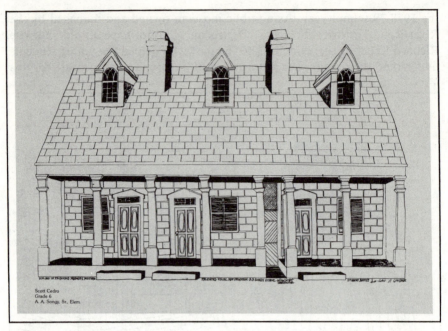

*Drawing of the Burgundy Street facade of "Sun Oak" by Scott Cedro, age 10.*

loss, the elementary students researched and emulated through role playing historic, late 18th and 19th century personalities who were directly related to life at "Destrehan." They were experiencing the past in a genuine way—using all of their senses—seeing, hearing, smelling, and touching. Costumes for the student tableau were made by their mothers; thus parents became involved and excited. The success of this aspect of the program was beautifully expressed by Tulane student, Janice Calomiris: "When I first interacted with the children, I almost viewed them as the link to the past. They had such a strong identity . . . this is my ground, and I want to see it beautiful!"

The program adopted fthe famed "Oak Alley Plantation" for the 1979-80 school year. Here the role playing tableau was expanded from the colonial period into the romantic, antebellum, Victorian, and 20th century when the mansion was finally renovated by the Stewarts.

For the 1980-81 school year the Songy students adopted "Glendale," an 18th century manor house and working sugar plantation. Here the students became acutely aware of the delicate ecological balance between man, nature, and technology.

Programs which are designed for continuity are built around a few central concerns that are given recurrent attention and modification each year. The focus for the 1981-82 Education Through Historic Preservation program was a comparison and contrast of Creole/Cajun culture with emphasis on Faubourg Marigny (urban Creole) and Bayou Des Allemands, Bayou Gauche (rural French). The program integrated the humanities class of Billie

24

Bumgarner and the accelerated social studies class of Carol Hite.

This project provided the Tulane students with the opportunity to deal with children's images of the country vs. the city, permanency vs. change, and architecture of the past vs. the present. The Tulane students under Dr. Cizek's leadership investigated the social psychology of design as it related to individual awareness to one's immediate environment. The Songy/Lakewood students were the target population. It was a mutual exposure learning experience, as expressed by Tulane student, Garcia Lombardi: "To me it was an opportunity to be exposed to another part of Louisiana and for that matter another type of geography and social behavior different from what I have mostly been exposed to, being from Latin America."

For the Creole aspect of the program, the students adopted "Sun Oak," the Nathan Lewis, Cizek house. "Sun Oak," built in 1836 was an excellent building to study because of Dr. Cizek's scholarly and authentic restoration. The following is an overview of our "Sun Oak" experience.

## GOAL ONE - ADOPT A LANDMARK

| Objective | Activities | Personnel |
|---|---|---|
| The student will have complete access to a restored Creole cottage, Sun Oak in Faubourg Marigny*. | 1. The students will be given a slide/lecture on New Orleans architectural styles. | Lloyd Sensat Dr. Eugene Cizek Billie Bumgarner Carol Hite Talented Student |
| *A neighborhood adjacent to the French Quarter of New Orleans which was developed in 1806 by a Creole Marquis Bernard de Marigny. This area is designated city historic district and is listed on the National Register of Historic Press. | 2. The students will be able to identify on a field trip to Faubourg Marigny the various architectural styles of New Orleans: Colonial, Creole, Greek Revival, Italianiate, Edwardian, etc. | Artists Humanities Students Social Studies Students |
| | 3. The student will tour Sun Oak. | |

## GOAL TWO - DOCUMENTATION AND INTERPRETATION

| | | |
|---|---|---|
| The students will be able to improve drawing skills. | 4. The students will draw (on site) the architectural details of Sun Oak; overlites, dormer windows, rusticated facade, Greek key entrances, columns, etc. | Lloyd Sensat Talented Student Artists |
| | 5. Using their on-site drawings, photographs, floor plans, etc., the students will render a sustained ar- | |

25

chitectural drawing of Sun Oak.

6. The students will interpret Sun Oak in various artistic media.

| Objective | Activities | Personnel |
|---|---|---|
| The students will be able to provide written documentation of Sun Oak. | 7. The students will interview and tape persons related to Sun Oak or Faubourg Marigny. | Lloyd Sensat<br>Dr. Eugene Cizek<br>Billie Bumgarner<br>Carol Hite<br>Humanities Students<br>Social Studies Students<br>Inhabitants of Faubourg Marigny |
| | 8. The students will trace the history of Sun Oak through archival research | |
| | 9. The students will read novels based on history of the times in reference. | |

## GOAL THREE - INTERACTION OF ELEMENTARY AND COLLEGE STUDENTS

| Objective | Activities | Personnel |
|---|---|---|
| The students will be able to interact with the architectural design students of Tulane University. | 10. Tulane, Songy, Lakewood students will meet at Sun Oak for drawing, interviewing sessions. | Lloyd Sensat<br>Dr. Eugene Cizek<br>Billie Bumgarner<br>Carol Hite<br>Talented Student Artists<br>Humanities Students<br>Social Studies Students<br>Architectural Design Students |
| | 11. Songy, Lakewood students will participate in Architecture Week at Tulane | |
| | 12. Tulane architectural design students will meet at Songy/Lakewood Schools for social psychology of design interviews. | |

## GOAL FOUR - ROLE PLAYING

| Objective | Activities | Personnel |
|---|---|---|
| The students will be able to emulate a famous Creole or former owner of Sun Oak. | 13. The students will be able to design with parental/teacher input an authentic Creole costume 1800-1982. | Lloyd Sensat<br>Billie Bumgarner<br>Carol Hite<br>Talented Student Artists<br>Humanities Students |
| | 14. Students will be able to discuss the life and times | |

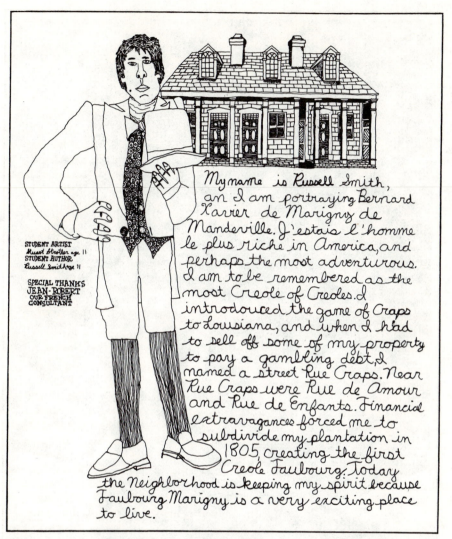

STUDENT ARTIST
Stuart Strother age 11
STUDENT AUTHOR
Russell Smith age 11

SPECIAL THANKS
JEAN-ROBERT
OUR FRENCH
CONSULTANT

My name is Russell Smith, an I am portraying Bernard Xavier de Marigny de Mandeville. J'estais l'homme le plus riche in America, and perhaps the most adventurous. I am to be remembered as the most Creole of Creoles. I introduced the game of Craps to Lousiana, and when I had to sell off some of my property to pay a gambling debt, I named a street Rue Craps. Near Rue Craps were Rue de Amour and Rue de Enfants. Financial extravagances forced me to subdivide my plantation in 1805, creating the first Creole Faubourg. Today the neighborhood is keeping my spirit because Faubourg Marigny is a very exciting place to live.

*Illustration of Marquis Bernard De Marigny with "Sun Oak" in the background, drawn by Stuart Strother, age 11. Commentary by student Russell Smith.*

of historic personalities that they have chosen to portrait.

Social Studies
Students
Parents

15. Students will pool their information to produce a student tableau on Cajun Creole lifestyles.

16. Students will give a tour of

*Student artist Brian Nolan works on a colored illustration of Annette Tronchet and Algernon Sidney Lewis, figures in the history of "Sun Oak" estate. The authentic costumes were researched with input from teachers, students, and parents.*

28

Sun Oak for Potpourri
Marigny III, a
neighborhood celebration.

17. Students will present
Creole/Cajun tableau for
Louisiana Landmarks
Society, Martha G. Robin-
son Memorial Lecture.

Students will be able to
draw
from a model.

18. Students will draw cos-
tumed impersonator.

Lloyd Sensat
Talented Student
Artists

19. Students will combine
figure drawing with
background to create
illustrations.

## GOAL FIVE - EXHIBITION

| Objective | Activities | Personnel |
|---|---|---|
| The students will be able to have a professional opening and exhibition at the Art Department Gallery, Newcomb College, New Orleans, Louisiana. | 20. Students will critique and select work for exhibition. 21. Students will use composite drawing to design an invitation to exhibition. | Lloyd Sensat Talented Student Artists |
| | 22. Students will participate in opening of exhibition and role play Creole/Cajun tableau. | Lloyd Sensat Dr. Eugene Cizek Billie Bumgarner Carol Hite Talented Student Artists Humanities Students Social Studies Students Parents Tulane Architectural Design Students |

## GOAL SIX - EVALUATION

This highly innovative and creative program does not lend itself to typical evaluative measures. Throughout the program the students were critiqued by their peers and their teachers. The most outstanding results of each short-term objective were kept for the annual student exhibition and printed publications. Framed and matted art work from each exhibition has remained at the Songy School and has become a part

*Student Russell Smith portraying Marquis Bernard De Marigny, "the most Creole of the Creoles," on the gallery of the adopted landmark, "Sun Oak," or the Nathan Lewis, Cizek House. "Sun Oak," built in 1836, is a rare and unique Greek Revival Creole cottage with a rusticated facade, a dog trot, and three separate kitchens. The New Orleans landmark was restored by Dr. Eugene Cizak.*

of the school's permanent children's art collection. The students' activities, art work, oral taped interviews from "Destrehan," "Oak Alley," and "Glendale" have been edited by Cizek/Sensat and presented as beautiful and exciting multi-media slide tape presentations to numerous national educational conferences. The Louisiana State Department of Education Gifted and Talented Section has produced a 16MM film on the program, "The Magic of Homeplace, Learning from the Built Environment".

All of the adopted landmarks have proven to be excellent teachers, as well as rich settings in which to learn. The landmarks have also given Lloyd Sensat the opportunity to teach the formal principles of art and architecture in terms of the real world. Sensat reflects: "Drawing is used in the interpretations because it is the most basic vocabulary of art; it makes great demands while using an economy of means—pencil and paper. Through drawing the landmarks my students begin to note structure, to heighten illustrative skills,

to analyze form, to create space, to explore formal elements, to sense historical time and to leave graphic records of themselves.''

The art/historic preservation program has had a positive impact on the young student artists' self-concepts, their future ambitions, their appreciation of the past and how it affects the present, and their ability to make decisions about the future of their own environment. When Marathon Oil Company demolished the 144 year-old Welham Plantation in the early morning hours of May 3, 1979, eleven year-old Steven Templet responded with a statement that was published in the *New Orleans Times Picayune*: ''I am a student in art and humanities at A.A. Songy, Sr. Elementary School. I was deeply shocked when Welham was rudely bulldozed. I think Louisiana should consider gathering funds for saving old homes or pass a law like ERPA, Equal Rights for Plantations Amendment.''

Welham was not the first plantation to be demolished quickly and without regard for local concern or public notice. Steve's reaction conveys feelings of a child emerged in the realities of physical change, growth, and decision making. Sixth grader, Scott Armstrong, reflected on his changing attitude toward art: ''Before I used to draw a lot of cars; now I draw houses. I like to draw, and now I feel I can better appreciate places like this.''

It should be obvious that the Art/Historic Preservation Program of the St. Charles Parish Public School System is not an extra curriculum or short-term demonstration project. Under the leadership of Yvonne Sandoz Adler, chief of Special Education for St. Charles Parish Public Schools, the program has evolved into a talented visual arts program. With the continued cooperation and support of principals Carolyn Woods and John Walker, A.A. Songy, Sr. Elementary and Lakewood Junior High have become the host schools. In addition, each year the Louisiana State Department of Education Gifted Talented Section has approved funding for the Model program through proposal submission. Funds in excess of $30,000 have been appropriated. This sum provided for all costs incurred for the multi-media slide/tape presentations, printed publications, and for the final presentation by the participating students. The program has been built and expanded on the success and knowledge gained from previous years. In the sixth year of the program, the young student artists will focus on New Orleans 1884 (past) - 1984 (present) and 2084 (future). Emphasis will be given to the World's Industrial and Cotton Centennial Exposition of 1884 and the planned 1984 Louisiana World Exposition.

Such an ongoing program opens greater opportunities for more people of all ages to become involved with the arts and learn to accept greater responsibility for the future of their environment.

---

*Lloyd L. Sensat, Jr., is Art Specialist for the Resource Center for Students Talented in the Visual Arts, at A.A. Songy, Sr., Elementary School and Lakewood Junior High School, St. Charles Parish Public Schools, Luling, Louisiana.*

# Options for the Artistically Talented

• LEE HANSON •

Most people will receive all the art classes they will ever have by the end of sixth grade. Unless a student decides to take one of the visual or performing arts as an elective in junior or senior high school, he or she may never experience any of the arts after the age of twelve. For this reason, the Chula Vista City School District in California has not only maintained a district-wide arts program, but has established an exemplary gifted program with an arts talented category.

The Chula Vista City School District covers an area over 100 square miles and is located between the city of San Diego and the Mexican border. It is the second largest elementary district in San Diego County, with a K-6 population of 14,000 students. Approximately 600 students (4.2%) are identified as intellectually or academically gifted, and 27 students (.18%) have been identified as artistically talented.

The handful of talented students is just a beginning. Two years ago, the District elected to expand the gifted program under new legislation (AB 1040) which included students talented in the visual and performing arts. This decision to expand has caused problems.

First of all, there were few districts elected to add academic achievement or one of the other categories). As a pioneer in the area of identifying and serving students talented in the arts, the district was faced with screening, admission, and appropriate instruction for these talented young people.

## Who Are They?

Before even beginning the program, it was necessary to define the population and educate staff so that everyone would know the characteristics of a highly talented student.

First the definition: Artistically talented students are those who originate, produce, perform, or respond at an extraordinarily high level in one or more of the visual and performing arts (in comparison to others his or her age).

In order to determine if students are exceptional, it is necessary to know what the "average" student is doing in the arts at any given grade level. For this reason, referrals can be made by teachers, parents, or peers. The characteristics demonstrated include some, but not all, of the following:

ART

_____ has accumulated sizable amount of art work (frequently drawing)
_____ shows originality
_____ is willing to try new materials, techniques, experiences
_____ uses art to express experiences, feelings
_____ is interested in other people's art work
_____ displays ease & dexterity in creating art work

MUSIC

_____ spends extra time in musical activities
_____ plays musical instrument or sings confidently
_____ has fine motor coordination
_____ exhibits a sense of rhythm

_____ displays auditory discrimination & memory
_____ makes up original tunes

## DANCE
_____ enjoys participating in dance/movement activities
_____ has well developed motor coordination
_____ moves with ease and assurance
_____ exhibits sense of rhythm
_____ displays high energy level
_____ remembers movement patterns & sequences

## DRAMA
_____ is able to dramatize feelings & experiences
_____ characterizes roles of people, animals, objects by facial expression, voice, gestures & movements
_____ imitates others; mimics people and animals
_____ improvises and moves dramatic situation to well-timed climax
_____ enjoys evoking emotional responses; loves playing to an audience
_____ writes original plays, dramatic story adaptations

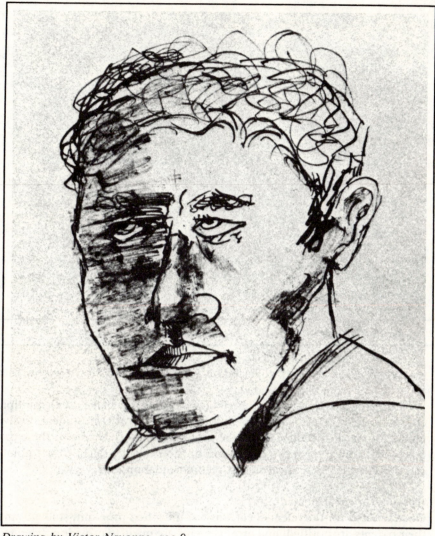

*Drawing by Victor Navonne, age 9.*

## Screening

Once referred, students are screened by a panel of experts during an audition or portfolio review. The auditions seem to work well, but after the first "review," it became apparent that looking at student art work had its drawbacks. The panel could not be sure that it was the student's work, nor could they determine the methods used. Consequently, the District added another step in the screening process—all students who are referred for visual art talent are bused to a central location for a day of art—working with art educators and professional artists to develop a mini-portfolio of drawings and paintings. Additional work by the student can be added by parents and

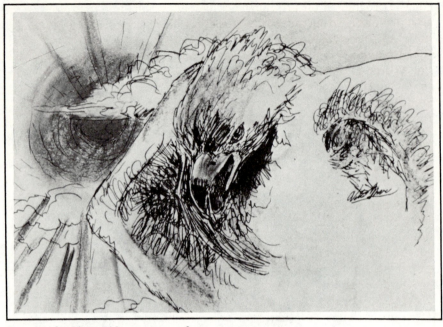

*Drawing by Victor Navonne, age 9.*

teachers, but the art work collected during the "art day" forms a core that is consistent from child to child.

During the audition or portfolio review sessions, the panel uses a multiple criteria form to determine a total number of points for each student; twelve points are needed to qualify for the program, and up to nine of these can be earned from the panel's evaluation of the student's talent (other points can be obtained from awards and recommendations).

### Options for the Talented

Once selected for the talented category of the gifted program, students and their parents are notified, and arrangements are made to provide accelerated instruction in the arts. This can best be provided at Kellogg, the District's Visual and Performing Arts Magnet School, and students are urged to transfer there. At Kellogg, professional artists as well as teachers and aides trained in the arts are available to provide exceptional opportunities.

Two of the primary goals of the program are to provide outlets and audiences for the most creative student work and to allow students to interact with professionals. Students are able to obtain a view of the real-life world by observing professionals functioning in the arts world (rehearsals, performances, studios, exhibitions).

### All the Arts

Since the students are young (in grades K-6), specialization isn't encourag-

ed. The program at the arts magnet school allows children to explore *all* the arts, while permitting individualization so that each student has the opportunity to follow his or her own creative inclination.

Not only are opportunities offered during the school day, but there are "noon drop-in" activities and after-school classes. This year, there have been some Saturday morning opportunities for students to work with artists. Students have also exhibited their work and performed in the community. A district-wide anthology of art and creative writing also provides an outlet for student art work. Most of these activities are available to talented students throughout the District, not just the ones who elect to transfer to the magnet school.

## Artists and Students
Many of the activities would not be possible without the influence and direction of the professional artists working in the schools. Although some artists and poets are hired directly by the District, many are funded by grants from the California Arts Council. The National Endowment of the Arts also provided funds a couple years ago which enabled Chula Vista to bring in two dance specialists and a major dance company for two-week residencies. These professionals have added a new dimension to the educational program for students as well as involving teachers in on-site training.

Additional teacher training has been provided under a IV-C grant which enabled the Chula Vista District to adopt New York City's highly successful "Learning to Read Through the Arts" project to the Kellogg magnet program. Since much of the school day in elementary school is spent in a self-contained classroom, the attitude and abilities of the teachers are important parts of an arts program.

## Environment and Process
An essential ingredient in any arts program, especially one in which students have displayed exceptional talent, is providing a safe, supportive environment. At the elementary school level, there is a great deal of emphasis on the *right* answer. There's only one acceptable answer to a math problem, and no one wants a creative speller. The arts can offer challenge (and a threat) since they require that the solutions to aesthetic problems be unique. Students are better able to work creatively if they are surrounded by peers, teachers, and artists who are accepting and encouraging. An arts magnet school can provide this as well as the increased stimulation so badly needed by highly talented students.

In the A/T program at the magnet school as well as in the special events offered to talented students throughout the district, emphasis is on the open-ended approach in solving aesthetic problems. Skill development is part, but a minor part, of a program which hopes to move children through the "basics" of the arts into areas which focus on analysis, synthesis, and evaluation. With A/T students, the goal is to go beyond the fundamentals, to ex-

tend the basic arts experiences so that students are involved in inquiry and problem solving processes.

For example, most elementary students have made collages while in school and hopefully have had some instruction in the elements of design and principles of composition involved in the activity. Extending the experience might take the form of developing a *sound* collage utilizing the expressive potential of the visual design by creating its counterpart in music. A collage in sound can be compared to a collage in art—both are composed of a variety of complete entities combined through sequencing, grouping, or overlapping to create a new entity. A basic concept in the activity would be to understand that repetition and change are important in giving shape to the expressive qualities of music and visual art. A further extension of the activity might be to develop individual methods of music notation, to record the sound collage, to develop shapes in movement and choreograph a dance which expresses the elements found in the visual and sound collages, and to present the variations at an exhibit or performance. Discussion would evolve around the great variety of shapes, colors, pitch, meter, texture, line, dynamics, space, rhythm found in the compositions, and how unity is created both internally and between the various arts. This type of interdisciplinary activity can strengthen each art form as well as guide the students into perceiving and discussing arts qualities.

## A/T Student Interaction

Perhaps one of the most important advantages of bringing A/T students together is the interaction that occurs. When isolated, talented students frequently lack the challenge necessary to push them to their creative limits. Many people, adults and children alike, are in awe of talent; the exceptionally talented student soon finds that he or she can acquire a great deal of praise for very little effort. When placed in an aesthetically rich and stimulating environment, the thoughts and accomplishments of peers and professionals trained in the arts can develop into an exciting interaction for the exceptionally talented.

All students, but especially the talented, need arts experiences which stimulate mental and aesthetic abilities, which allow and encourage many solutions to aesthetic problems. In addition, A/T students need peer and adult models who display high levels of ability and who view positively the unique products of others. This development of a broader view of the world than can be found in an exclusively cognitive focus is the ultimate goal of a program based on the needs and abilities of these highly talented individuals.

*Lee Hanson is Curriculum Coordinator Art and Gifted Education, Chula Vista City School District, Chula Vista, California.*

# Project Challenge

• SUSAN E. SUTLIFF and ROXANNA SMITH •

Like father, like son. Even at an early age, John enjoyed watching his father draw—the subject did not matter. The boy proved to be a quick student with natural talent who spent hours entertaining himself with pencil and paper.

"One evening we were sitting in the living room drawing the stone fireplace," the proud father recalled. "When we put our pictures together, you couldn't tell the difference."

John, the quiet son of a truck driver, excels in art just as he does in his other academic courses.

\* \* \*

Claire comes from a well-to-do family. Her parents considered her older brother to be the child showing the most potential in art, but now Claire is taking private lessons and is placed in an advanced art class in public school.

\* \* \*

These are just two of the many examples of children exploring the world of art through the Anderson, South Carolina, School District 5 Project Challenge visual art component for the gifted and talented. Limited to students in grades 4-6, Project Challenge art provides enrichment opportunities for all types of young people.

Although the program is still young and constantly changing due to fluctuations in funding, Project Challenge director Anna Pruitt sees many benefits for its existence.

"It will definitely provide the students with experiences they'll not get in the regular art program," she said.

With small, homogeneous groups of students, the instructor can give the specialized training that gifted and talented children need. The children are also exposed to other children with similar talents and to a variety of adult personalities.

"Opportunities for private art lessons are limited in Anderson," explained Mrs. Pruitt. "The program fills that gap. We provide opportunities for them to explore different media and perhaps to centralize their own interests once they know different techniques," she contended.

Such a program could never have been developed without local district financial support for a strong secondary art program.

"Art adds a new dimension to one's perspective on life," believes superintendent Dr. William B. Royster. "Because music and art work closely together, we try to maintain balance in funding dollars for these programs."

At the time the original grant was written, Anderson School District 5 did not employ elementary art teachers. Art instruction was handled by the regular classroom teacher. Art supervisor Roxanna Smith provided special lessons

and assistance as requested. Students did not receive regular, formal art instruction until they reached junior high school.

Funds for Project Challenge art came from a $40,000 competitive grant awarded to the South Carolina State Department of Education by the federal government. Anderson School District 5 received one of three $13,999 grants for visual and performing arts awarded to local districts for 1980-81 and 1981-82. Now that the block grant system is in effect, only $4,000 was received this year.

Just as the students have varied backgrounds and developmental skills, so has the program varied. At all stages, it has remained a supplementary instruction program.

"It's a constantly evolving program," explained Mrs. Smith. "It changes with staff and available funds."

At its conception in 1980, the gifted and talented art program was designed to fill a need for elementary students. Specially selected pupils were pulled out of the regular classroom and transported to Concord Elementary School. There they worked with Project Challenge art teacher Deane King for four hours a week. Additional classes were held after school for all students who had been nominated for the program, (The after-school component was discontinued after one year.)

When Project Challenge moved to its present location at North Anderson Elementary School in the fall of 1981, the additional space available there enabled another shift in how the program was set up. Six professional artists were hired part-time. On a rotating basis, each met with groups of 10-15 students for six-week sessions.

This year the program has returned to using one part-time certified art teacher, Mrs. King. In a total pull-out program, she meets with the students for two hours a week. Professional artists will be invited to give enrichment lessons later in the school year.

In spite of these annual changes in instruction, the purpose of the program has not waivered.

"The goal is to provide children who show unusual talent in art with in-depth studio art experiences in drawing and painting," explained Mrs. Smith.

Currently, screening for the program occurs in the fall. About 30 students who participated in the prior year's program automatically return to the class. The six elementary art teachers now employed by the district nominate about 200 students that they feel show promise in art. Each child is required to submit a portfolio consisting of three drawings: their hand, a self portrait, and a still life with at least three objects. In addition, Mrs. Smith conducts a formal lesson during which students must produce another still life drawing.

"Some of the most exciting experiences have come during the screening process," said Mrs. Smith. "A fourth grade boy spent over an hour on a drawing of his own tennis shoe, showing sensitive line quality and visual discrimination skills far beyond his chronological years."

Other children, Mrs. Smith discovered, draw in a very unique personal style at a very young age. Deliberate distortion in the drawing styles of two

Photo credits: Roxanne Smith

*Drawing by Paul Matheny, grade 4, Concord Elementary School, S.C. Teacher: Andy Pickens.*

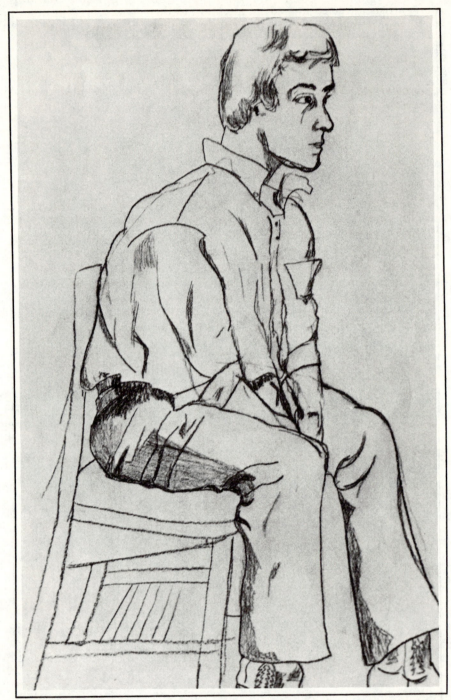

*Drawing by Jason Czepiga, grade 6, Calhoun Elementary School, Anderson, S.C.*
*Teacher: Andy Pickens.*

young artists attracted immediate attention to their work.

The four drawings are evaluated by four judges. The review panel consists of the child's elementary art teacher, the Project Challenge art instructor, a professional artist from the community, and Mrs. Smith.

Using a standard rating form, the judges grade each student's work based on seven criteria. These are detail, composition, line quality, positioning, proportion, perspective, and creativity. They narrow the field to 30.

This year, Mrs. King is exploring different materials in depth. All her projects stress line, space, form, texture, color, and creativity.

"Drawing is the underlying factor in all projects," she explained.

Most recently, the students designed stuffed sculpture mobiles of food. Authentic looking, over-sized bananas, pickles, ice cream cones, hot dogs and hamburgers—complete with an assortment of appropriate toppings—filled the room. Once completed the mobiles will hang in the classroom and at various community exhibits. Next, the class will make life-size papier maché sculptures.

Later in the school year, Carol McDaniel Clark will return to teach enrichment classes. The nationally known watercolorist taught during 1981-82 and has selected participants for the program. She salutes its progress.

"Art has been one of the most neglected things in education in the last 10 years," she complained. "Project Challenge art is such a worthwhile program. It's really a necessity."

The first children enrolled in the program did not have much, if any, formal art training.

"The majority of children are creative, but if you go through the first three grades and you don't have any (art) experience, you're hindering their emotional and motor skills," Mrs. Clark contended.

Students in her classes "ranged from homes that had everything to those that had nothing." Mrs. Clark described one child who, after being chosen for the watercolor class, has second thoughts. He confronted her with his displeasure and said he'd rather be swimming with his classmates (in the district's physical education program). From talking with him, Mrs. Clark found that "he couldn't even spell his name, and he had emotional problems from the way he was treated at home."

Eventually, she talked him into staying in her class. "He did the most lovely painting I'd ever seen," she added. "Now, here's a child who people would write off as an academic loss."

Project Challenge art is not easy. In her classes, Mrs. Clark worked four hours a week on watercolor design, composition, and color value.

"Much of the work," she said, "is above their levels, but they really comprehended well. The finished products were just magnificent!" she exclaimed.

Another professional artist, Andy Pickens, had never taught before and was somewhat apprehensive about joining the Project Challenge staff. The commercial artist found, however, that "the kids wanted to learn and discipline wasn't a problem." He primarily taught figure drawing with pencil, but also stresses the importance of coming to terms with yourself as an

artist. Although Pickens believes figures are the most difficult to draw realistically, he felt the children possessed an advantage.

"They don't have the learned inhibitions that grown-ups have," he said.

Janet Wagner also worked with figure drawing, but in charcoal and with an emphasis on portraits.

"Basically, I was trying to get them to not be afraid of drawing people," she explained. "I was trying to get them to see light and shadow, positive and negative space."

This, too, was her first experience working with gifted young children. Their energy surprised her.

"I had to be pretty well prepared," she said. "They'd zip through exercises, one, two, three."

Some students appeared afraid of new ideas. Mrs. Wagner attributed this to the new learning situation.

"The students were secure in being good or talented in their individual schools, but were intimidated to be grouped with students of similar skills," she observed. "It was good for them."

Graduates of the gifted and talented art program are automatically placed in Art I in junior high school rather than the seventh grade mini-course. In Claire's case, the advanced placement worked well. Her teacher Kathy Cauthen reported that in the beginning Claire seemed slightly afraid. The class is predominately comprised of eighth and ninth grade boys. Three months into the school year, Claire now "acts as if they don't even phase her."

"Claire is one of the few of my students who extends herself beyond what's expected of her," said Mrs. Cauthen. "She takes an assignment and gives it 110 percent. She always takes it another step further."

Saying this seventh grader is "above her years" in maturity, Mrs. Cauthen also cites her supportive home life as another reason for Claire's success. Other students coming out of the gifted and talented art program also show exceptional ability, but some lack emotional maturity.

Project Challenge staff members continue to build and change the program as new students are selected. A strong feeling of success has followed their efforts during the last three years. Mrs. Clark summed up the situation well when she said, "Once they learn art, it's something they'll carry throughout their lives."

---

*Susan E. Sutliff is Public Information Officer, and Roxanna Smith is Art Supervisor, Anderson Public Schools District 5, Anderson, South Carolina.*

*Mrs. Pruitt and Mrs. Smith would be happy to share additional information about this program. You can contact them at Anderson School District 5, P.O. Drawer 439, Anderson, SC 29622.*

# Creative Art and Printmaking Program

## • ANN PETRILLA •

Three years ago, after teaching art for 14 years in grades one to eight, I realized the need for a program for the gifted and talented, for we had so many students in our school working above average grade level in art. The gifted/talented have often been the overlooked segment of our children. When the opportunity to apply for state grants for the gifted/talented became available, I asked my principal if I could apply for a grant to establish a program in our school for the talented in art. My idea was to help develop their talents using a cross-grade approach to carry out original projects in an interdependent atmosphere. The climate for artistic achievement did not exist. The existence of the gifted/talented in art was not recognized by either the parents or the community. During their early childhood these students were not offered any enriched programs with challenge to develop their exceptional talents. The principal, Sr. Mary Joel, was receptive to the idea.

I knew very little about applying for a grant. Some of our parents volunteered to form a committee to investigate and learn about writing and applying for grants. I soon discovered that writing a grant was no easy task—rules, regulations, format, proving your needs, etc. There are eight sections to a grant application, with statistics and estimates; it took many hours to compile the information necessary. The first step was testing; fortunately I had always evaluated all my students' progress yearly—evaluations which I gave to all classroom teachers every year. I used the Lowenfeld Profile of Creative and Mental Growth stages of development and a test I devised in creative drawing for each grade level. This gave me solid evidence that 187 students measured from 10% to 50% above average grade level development in art. We had to narrow this number down, so we further tested using the Renzulli and Hartman scale for rating behavioral characteristics of superior students. From this, 47 showed superior ability. The application was filed in December 1979 and was granted in June 1980. We had filed the application for a class of 36, so in the interim between December and June, I kept very close records on the 47 students and also interviewed their teachers to check their progress in other subject areas. With this information I narrowed the group down to 36 students. We were ready in June when the mini-grant was given to us. We never actually saw the money; everything was filed through the New York City Board of Education District 27. They helped us a great deal with all the necessary paper work.

Of course I was overjoyed and very excited to start on my new adventure, but little did I know the real work was just beginning. When working in unchartered territory, there is always the possibility of failure, but I had con-

fidence in the students. If there was any failure, it would be my fault.

We had applied for $2,720 but were granted the sum of $2,200; this meant I would have to cut down on some of our materials. I spent the first month and a half of the summer seeking bids for all major purchases. The lowest bid on each item was the one chosen. This was the method used to purchase work tables, chairs, and art materials, plus the presses and the equipment unique to printmaking.

We called our class CAPP which means "Creative Art and Printmaking Program." The class is intended as an introduction to the creative art and printmaking graphic arts techniques. The class is integrated into the normal curriculum and consists of 36 students from grades two to eight. We meet once a week for an hour in the art room. The students are required to make up any work they might miss from their regular subjects. Since these students are gifted children, this has not been a problem.

The students work with art kits consisting of pencil, pen and ink, markers, rulers, erasers, and drawing pads carried in red rope envelopes, all provided by the grant. After instruction by the teacher, several sessions are devoted to students developing original designs and environmental drawings. The teacher aids the students in refining and preparing their drawings for each

*Sabrina cutting linoleum block; Sal in background, etching; grade 6 students.*

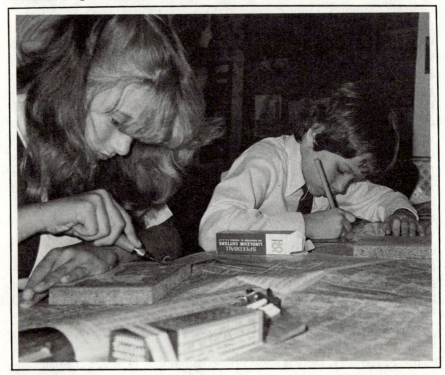

printmaking process. Four basic methods are used: relief, intaglio, lithography, and silk screen. The processes were demonstrated as they were introduced for the first year. For this we had professional consultants, MaryBeth Giraci, a fine artist; and Kathleen Troy, a printmaker. They both had special expertise in methods and techniques to offer and were very interested to be working with this special group. Now the students who are proficient in the printmaking processes, assist the new students added to the class as students graduate.

We do wood and linoleum block printing, with older students doing some reduction block work. We do drypoint etching on plastic and plexiglass plates (because we are not allowed to use the acid necessary for biting the metal plates). Lithography is done on litho-sketch plates, and silk screen on paper. This year we hope to add t-shirts. We have a Speedball Printmaster press and block presses, with all the brayers, cutting and etching tools, the special inks and paper necessary, all purchased under the grant. Each year we only have to replace the consumables such as printing paper, inks, wipes, broken tools, pencils and pads, etc. We also do pen and ink drawings and scratchboard; sometimes this helps the student to visualize the print. This year we are adding collagraphs and monoprints.

*7th and 8th grade students silkscreening.*

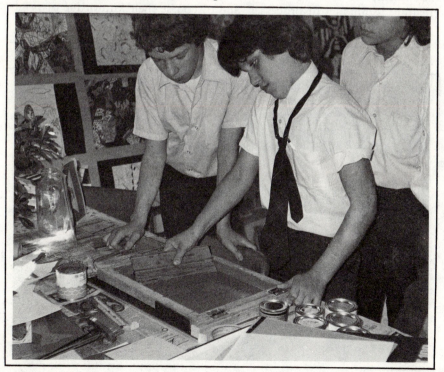

A trip is planned each spring to the printmaking department of the prestigious Pratt Institute in Brooklyn. The chairman of the department, Mr. Toulis, always welcomes us warmly. This is an invaluable opportunity to visit printmaking workshops in action. The students are given a guided tour and demonstrations in each printmaking technique. During our last visit we were honored to have Ms. Clare Romano, co-author of *The Complete Printmaker,* as our lecturer on etching techniques. The students are always impressed with the college workshops, but the college faculty and students are equally impressed by our group and what we are doing.

Oral and written exams are given, and each student must produce at least four prints in each of the processes, in which originality of design and execution of the techniques are evaluated. Advanced students may now produce editions on the same theme. Book reports are also required on printmaking processes and artists.

The year is terminated with an impressive original print exhibit by the students, for parents and friends. We send out invitations and do printmaking demonstrations, and samples of prints are given out to those attending the exhibit. The CAPP students are so enthusiastic and supportive of one another and very eager to share their knowledge with those attending the exhibit.

The original evaluation objectives for the grant were not only met but far exceeded all my expectations. In fact, I found a great improvement in all the students' work (this year 60% were rated excellent), in their methods of creating, techniques of processes, and of course their knowledge of print-

*Michael and Thomas, grade 6, printing their etchings.*

*5th grade students: Tricia etching on plexiglass; Maggie drawing on litho plate; Betsy cutting her linoleum block.*

making. Eight students in the past two years have taken the entrance exam for the High School of Art and Design in New York City and were accepted. The program has been an incentive for others to achieve honor roll status in order to qualify for CAPP, because they derive special skills and knowledge and gain prestige, self esteem, and recognition for their talents. Many of the students who are gifted are usually looked on as "different" by the rest of their peers, and in some instances are not accepted by them. Now they are accepted. Many of these students may go on to an art career, I really do not know. But I do know we will have a group of knowledgeable consumers and patrons of the arts someday.

The CAPP program has been so outstanding that the parents have agreed to fund the program themselves. Last year we got by with $6.00 per student per year; this year we needed $10.00 per student because we are adding new materials plus replacement of our consumables.

CAPP is not only innovative and unique for an elementary school, but challenging as well as intellectually appealing to the gifted/talented, at whom this program is directed. It has also been very stimulating and challenging for me as well. This motivation carries over into my regular art classes and makes my work more rewarding. A program such as this is not only beneficial to the school and its students but to the whole community.

*Ann Petrilla is Art Teacher at Holy Child Jesus School, Richmond Hill, Queens, New York.*

*Sharon Lindquist building the perceptions of preschoolers.*

# Extra-Ordinary Art Classes

## • CHARLOTT JONES •

During the last eleven years I have built a program which has burgeoned from four children to almost 100 who participate in after-school art classes each week. The program was conceived through the initiative of a mother's request, and the original purpose was simply to teach children to make good art, to realize their skills and understandings, and to present challenges which would allow for more complex processes and would elicit superior products to those a large or average classroom could provide.

**Population**
From the beginning I insisted that only children who wished to take art classes and have a commitment to continue in them be allowed to participate. With parents I insisted that there be no gentle arm twisting to force their children into an after-school activity. Current studies in gifted/talented programs identify a triangular paradigm with ability as one component, task commitment as a second, and creativity as a third. "The greatest gift of all," Joseph Renzulli (1982, p. 14) has written, "is the person's desire to create and produce." And the program is based on this belief. The concept of talent was recognized as an aptitude which spurred an interest or engendered a skill. Usually this was identified by an observant parent or classroom teacher. (How many times have I pricked up my ears at the words, "This child draws all the time!"?) The desire to make art was the *sine qua non* of the program and continues to be so. Gradually the student population grew until it spanned the years of ages four to eighteen and was divided into groups of eight or fewer children. If the aptitude is slight, the child eventually loses interest, but during the interim has learned something about art which ordinarily the schools are unable to teach to groups of 15, 20, or more children.

The goals of the program grew with the population. The children's classes became a field study which enriched my art education classes at Arkansas State University. The questions which were generated by these sessions became a philosophical base for exploring the authenticity of child art. (A man from another town on viewing our exhibit one year at the local mall asked if the works were really done by children of the ages listed on the labels. When the answer was yes, he turned to his wife and said, "We've thrown away a fortune!") We—the children, my associate teachers, and I—have searched for a clearer understanding of how we learn to make art. What are the areas in the process of art making which should come from within the artist? What should be provided by the teacher?

The venture has provided a confrontation with the reality of today's child as learner, and always there has been the challenge of being the actual cause

The Library
Saint Francis College
Fort Wayne, Indiana 46808

of children's learning art. As in most successful elementary teaching/learning situations, this has meant demanding, cajoling, inspiring, insisting, coaxing the work from the children. The teaching process is visual as well as verbal. They see slides of their own work and that of others—professionals and children. Every child has work publicly displayed in a large annual exhibition. Their work is entered in competitive shows, and their parents are encouraged to frame and hang successful works. Their art skills accord them esteem in their schools, and many teachers have told me these children act as catalysts for learning in their regular classrooms.

## Location

The setting for the program has grown from a large glass and stone back porch facing a yard where trees modeled patiently for young artists for ten years, to three back rooms of my house, to—in the not-so-distant future—the entire second floor of a large old home on the National Register of Historic Places, the "Frierson House." Now under restoration, its neoclassical facade and large wooded lot already provide an environment for art making. The location is Jonesboro, Arkansas, a small city of between 30,000 and 40,000 people. The local area has not had a rich cultural heritage, but an outstanding art faculty at the university here has now provided a professional art community which generates regular exhibitions of art.

I began the project before I started teaching art education at Arkansas State University, and before I went to Penn State to earn my doctorate. Upon my return from Pennsylvania, my contract with the university here became full time, and the classes with children continued, serving as an inspiration to the art education majors and providing them with examples of children's works, both successful and unsuccessful, to observe and judge. When the number of participants demanded more time than I could devote to them, I asked the wives of two of my colleagues to associate themselves with me.

Currently staffing the program are four women: myself and three other instructors. Sharon Lindquist, a professional weaver, holds a degree in art education, and taught in the Iowa City schools while her husband was earning his MFA in printmaking there. In addition to teaching the pre-school children, she teaches weaving to special interest groups. Brenda Keech is a painter, holding a BFA degree; she is the wife of a painter, and they have a three-year-old daughter who does some painting. Brenda's classes here are open to students in grades seven through twelve. Jill Davis teaches art at Nettleton Middle School, holds a BFA with teaching certification, and teaches the Saturday class for children who cannot come after school—this group is composed of children from grades one through five.

## Instructional Program

The program is structured for the age and maturity of particular groups of children, generating and exploring ideas with them in the process of building awareness of the elements of art and how to use them successfully.

*"Spring Flowers," oil painting by Shari Kelso, age 13.*

### Pre-school

Pre-school classes meet for two hours each Monday afternoon. This is longer than other classes, the reasoning being that some pre-school children would have neither kindergarten nor nursery school experience, and two hours of structured work in the week would be beneficial. The two-hour sessions also accommodate mothers, the second hour allowing them time for their

own pursuits before reclaiming the children. Cognizant of the needs of children at the ages of four and five, the teacher plans that the activities which fill their two hours include a break for cookies and creative play. This ranges from games which teach them the primary and secondary colors to treasure hunts in the yard for live snails, strange rocks, or wild flowers "All things counter, original, spare, strange," as Gerard Manley Hopkins wrote in "Pied Beauty."

The lesson plans anticipate short attention spans early in the year, so multiple follow-ups are planned with each activity. One class begins with a ten-minute identification of shapes, naming basic geometric shapes cut from bright colors. The children then move on to observing the teacher cut shapes from scrap papers while calling on individual children to name them. They match halved poster board shapes on their work table and then draw any picture using the shapes studied. They are invited to show their pictures and explain where they used the shapes. Another activity is having a child as model, while the group, through drawing the model, discover the same shapes presented in the previous activity. If the weather permits, the students go outdoors and look for the shapes in nature. Reproductions of works like Rouault's *The Old King* and Carroll Cloar's *Halloween* are used to discover how the artist uses shapes in paintings. This succession of encounters builds interest and involvement and progresses at a pace with which the group is comfortable, allowing them to study a work in depth or discover the art process used. By April or May interest can be sustained for an hour or more in a lesson which lasted only five or ten minutes in September. In one instance children were still hard at work on wood assemblage sculptures after two hours. Even cookies couldn't distract them.

**Elementary**
With long-range plans for the school year which include drawing, painting, printmaking; clay, wood, wire, and three-dimensional paper activities; observations and discussions of the art heritage which is theirs; and critical awareness of art products, flexibility has remained a key factor in the instruction. The freedom to adapt readily to mood of the group, to events of the day, to the individual child acts as a catalyst for artistic growth and expression. Human imagination is a vagrant. Unable to be harnessed like a workhorse, it requires the kind of discipline to which a thoroughbred submits, that is, regular exercise, a sensitive hand on the reins, positive encouragement, and the right nourishment.

Beginning with grade one and continuing through grade six, the children are taken to the Arizona State University Museum where each child can choose which of the mounted birds and animals to draw; the children are led into the neighborhood to observe and draw old houses, trees, firetrucks. This heightens perception, strengthens drawing skills, and builds visual memory. Out of these pencil drawings grow studio activities, both two- and three-dimensional. Drawings of houses serve as studies which develop into

crayon resists of fantasy houses; trees are transformed into the habitats of creatures from never-never land; animal drawings are the sources of clay modeled sculptures; drawings of large birds are worked out in batiks. Beginning in fourth grade, these drawings are also sources of silkscreen designs. The openness demanded to set aside well-laid plans for an afternoon's work on occasion when the children beg to go out and draw demands flexibility from the teacher and maintains a high level of involvement from the students. The effort is to constantly stimulate that facet of imagination which invents as well as that which observes and recalls. Again and again we reinforce the idea that the artist has the freedom to select from nature, to rearrange, to omit, to create, always to choose.

## Secondary

Grades 7 through 12 work in studio art interest groups. Their options include calligraphy, ceramics, oil painting, pencil drawing, and weaving. Each of these options is structured in a nine-week unit, meeting for one and one-half hours each week.

*Painting.* In painting, we attempt to train the eye to relationships of shapes and colors. For their first oil activity, a still life is set up, and the students are asked to do a simple line drawing in charcoal, filling their canvasses. If the drawing is inaccurate, the painting will be problematic, so the stress is on perception—how to see things. The instructor responds to the individual, and only if the student asks, does she suggest what color to use. She urges them to use as large a brush as possible to cover an area; not to dab but to work in nice, long strokes, to cover with a minimal number of strokes. They work with a limited palette on stretched canvas. The method is to have them underwork their paintings.

After this first painting is complete, in two or three lessons, the second is a very elementary still life of a few pieces of fruit which they finish in one class; two, if one simply will not suffice. This works to reinforce their conviction that they really can make satisfactory paintings and avoids the common flaws of overworking, picky detailing, specific on top of specific. This artist/teacher moves her students from general to specific, using constant commentary, and working for fresh color. After the second still life, the students go outside to select an area of the environment to paint, or they paint a landscape from the window of the studio. Choices, choices, there are always choices; and from these options grow the responsibilities for making their own art. Two student painters have won prizes at the Junior Mid-South Exhibition in as many years.

*Weaving.* The loom is to the weaver what brush and canvas are to the painter. Because the teacher is an artist herself, and a superb teacher as well, she has prepared books of beautiful samples to show the students and to inspire them with what can be done with various threadings of the loom. She believes they must understand the loom as a tool employed for the making of creative statements and that before they can be served by it, students

*"Charlott's Fantasy House," silkscreen print by Marlo Grisham, age 10.*

must achieve control over the loom by comprehending its total operation. This is achieved by going through the entire process of weaving from the beginning, in a logical step-by-step manner. The final essential step of the instructional process is the evaluation by the teacher's and the student's appraisal of textural quality control of selvages, control of draw-in, appropriate finishing, effective use of design and color, and suitable use of yarns. The ability to speak the language of weaving is acquired naturally in this way, and the student's vocabulary grows as the process logically unfolds. By allowing these skills to become second nature, the student is liberated to concentrate on working freely and creatively with color and design. Artists in their chosen medium, fibre, four of the student weavers had works accepted in the Junior Mid-South Exhibition this year.

**Cost and Financing**
The direct, out-of-pocket cost of the program slightly exceeded $5,000 in 1981; overhead, another $5,000; and all other revenues were expended on improvements to the present teaching facility plus acquisition and restoration of the "Frierson House." Equipment costs fluctuate from year to year. There are now six electric potter's wheels, two electric kilns, one three-foot

56

catenary arch gas kiln; four LeClerc four-harness table looms, twenty-four tapestry looms; easels; silkscreens; drawing boards.

The program is financed through student fees—$20 per month for grades one through three; $25 for pre-school and grades four through twelve. I supply almost all materials. This program is an example of private enterprise, barter, and philanthropy in education. No public monies have been expended on the program itself. Children's participation in the art classes has been bartered as trade for lawyers' fees, accountants' fees, computer services, and some

*Shannon Lovejoy and Mary Margaret Stallings, age 8, helping with the first "Frierson House Clotheslines Show, 1982.*

equipment and professional consultation used on the restoration project. Full and partial scholarships are granted annually by grandparents, professional people who are generous in support of education, and by me. At least ten of the children in the program this year fit in these categories.

The Frierson House itself has received a $35,000 grant through the Arkansas Historic Preservation Program; over $100,000 has been applied to date on the project. The property acquisition costs will continue for the next twelve years and private monies as well as tax credits will continue to be applied to its completion.

## Results of Program

There have been works by children from these classes accepted in the Young Arkansas Artists Exhibition each year. From fifteen hundred submitted the Arkansas chapter of NAEA selects about three hundred to be hung. We had twelve pieces selected last year. The local schools have been encouraged to participate in YAA by my assistance with transportation of works. In this way the classes have helped to increase the art activities for all the children in Jonesboro schools.

Any young person from with 350 air miles of Memphis, Tennessee, is allowed to submit one work to the Brooks Museum Junior Mid-South Exhibition each year. This show employs a juror from a major museum such as Cleveland and Chicago. In 1982 fourteen works produced in these classes were counted among the one to two hundred accepted. Of these, four won prizes.

One "graduate" of the program—Rusty, a little boy whose mother asked me to "teach him" when he was in second grade—is not a pre-med student. A second—Mac, whose mother initiated the entire enterprise—is working to get in medical school. The art and music backgrounds of these young men will enrich many lives as they pursue their chosen profession. At least three former participants are now college art majors. The future of these children should weave a beautiful tapestry of achievement, service, and rich humanity. The tale has just begun.

---

*Charlott Jones is Assistant Professor of Art, Arkansas State University, State University, Arkansas.*

**Reference**

Joseph Renzulli, "Dear Mr. and Mrs. Copernicus: We Regret to Inform You . . . ," *Gifted Child Quarterly*, Winter 1982, Vol. 26, No. 1, pp. 11-14.

# New York City's
# Music and Art High School

• SHEILA STEMBER •

Music and art may be the major concerns of civilization, but they are still minor subjects in school. Not so, at the one-of-a-kind Music and Art High School in New York City! Founded in 1936 at the request of Mayor Fiorello H. LaGuardia, it provides a facility where the most gifted and talented of New York City public school students pursue their musical or artistic talents while also completing a full and difficult academic program. Of the 2,000 students enrolled, 800 are art majors. (The other 1,200 are vocal or instrumental students.) The school is housed in an old school building on the campus of the City College of New York in Harlem, but expects to move, within a year, to a specially designed new building in the Lincoln Center for the Performing Arts complex in midtown Manhattan.

The students come from all parts of New York City, often traveling great distances, and represent every racial, religious, ethnic, economic, cultural, and social level. Admission to the program is by presentation of a portfolio and a performance test; for every ten students who apply, one is accepted. Students are screened for aptitude, capacity, and interest rather than previous study; they must read on, or above, grade level, demonstrate achievement in all subjects, and are expected to maintain themselves in the demanding academic curriculum. All studies prepare students for college, or for further study in art at art schools or art colleges. Every art student is scheduled for a minimum of two periods (forty minutes for each period) of art a day, and in the junior and senior years can take up to four periods of art a day. A one year course in Art Survey (history of art) is required in the senior year.

The FIRST YEAR of studio art is given to entering students whether they are "4 year" students, entering in the 9th grade, or "3 year" students entering in the 10th grade. The first semester, Studio Practice 1, is devoted to drawing and painting in tempra. The emphasis on drawing is rigorous, and is continued in the following years. The student is asked to draw from observation using various media: pencil, charcial, crayon, conte, pen. He learns to set down quickly the essential lines; he learns to draw without line; he is introduced to the need to compose on the page. He draws still life objects, fellow classmates in seated, standing, and action poses, animals (stuffed), flowers, and fruit, trees and landscapes, buildings and architectural details—in short, anything. A sketchbook is required. Homework is assigned, and generally, on Monday mornings, the first activity is a group evaluation of the sketch book entries. The drawings, which are continued throughout the years, may become the basis for future works in drawing, painting, or print-

making. At the end of the first semester, the use of tempera is introduced because it is easily managed and develops skill and assurance in painting. The second semester, Studio Practice 2, is given to developing skill in painting with transparent water color, with continuing emphasis on drawing and composition. Again, still lifes, figures, landscapes, and seascapes are the subjects.

In the SECOND YEAR, the first semester, called Studio Practice 3, gives students experience in pure design. Using only cut paper, and then ink, students design in form, shape, texture, line, and planes. Later, the element of color is added. Frequent class evaluation and the intensive experience enable students to achieve a deeper understanding of composition in art. The second semester of this year, Studio Practice 4, is devoted to basic oil painting based on the drawing, painting, and design experience of the three previous terms. Students work on canvas board, beginning with monochromatic palettes to gain experience, and then go on to a full palette, painting still lifes, figures, and landscapes. The sketch book is continued and frequent evaluations and discussions are held. All of the art activities, whatever the subject, are directed toward effective design and visual satisfaction. From the beginning, students learn to select, omit, modify, accentuate, or subdue, arrange or rearrange material and develop techniques. They forego the tendency to be impressed by mere technical skill in representation and to try to copy nature. In the THIRD YEAR, after the four terms of basic studio practice courses, students are able to elect their double period of studio art from among the following:

- *Advanced Painting* is for students who have proven themselves to be most creative and able in oil painting. Students work on stretched canvas, and often on individually selected and planned projects.
- *Advanced Water Color* is for students who have excelled in the basic course. They continue experimentation in the media, use special papers, and paint figures, still lifes, portraits, landscapes and seascapes, or whatever else is of interest specially.
- *Architecture* begins with basic principles and the study of architectural symbols and terms, and goes on to elementary plans and working drawings, architectural renderings, scale models, and finally, an individual project. Interested students work on stage designs for the school's musical plays and operas, doing the scenery and constructions. This year, a project developed as an introductory problem for the class, entitled "Monument to Myself: Self-Awareness through Model Building," was selected for a grant under the IMPACT II program funded by the Exxon Corporation and the Board of Education to disseminate successful and innovative teaching practices.
- *Advanced Ceramics* has as its prerequisite mastery of basic ceramics. In this advanced course, students are taught wheel-throwing and ceramic sculptural forms. Techniques in glazing, and in stacking and firing the three kilns are included.
- *Advertising Art* includes advanced lettering, page and poster design,

*A drawing from illustration class, which utilizes drawing and design skills developed in basic studio classes.*

paste-up, and press-on textures and letters. Students study advertisements, and are equipped to prepare the dummy, layout, title page, and illustrations for the school publications—a literary art magazine, and yearbook—programs for concerts, plays, and ceremonies, as well as other student activities such as student government elections. Visits to graphic designs studios provide liaison to the world of work.

• *Stone Sculpture* uses alabaster (an easily worked stone that is non-toxic) based on clay models, and occasionally, for interested students, instruc-

61

tion in the lost-wax technique of bronze casting. Students take a class trip to a supplier to pick out their own stones after making their models.

- *Advanced Printmaking* has as its prerequisite the basic printmaking course, and goes on to woodcuts, color prints, and etchings.
- *Advanced Drawing* students work at sketches as well as finished drawings of still lifes, the environment, and figures.
- *Fashion Art* is taught from the standpoint of design, emphasizing use of varied sources of design and creation of original, makeable garment designs for women's and children's wear. Interested students may design costumes for the theatre, and all students are introduced to fashion illustration techniques.

Required Single Period Classes are given in the third year for "4 year" students and the "3 year" students who are not taking advanced classes in science, mathematics, or language. These classes are *Basic Ceramics* and *Basic Printmaking*. In the ceramics class, the students explore basic handbuilding techniques in pottery, and creation of sculptural forms in clay. In the printmaking class, students use linoleum for single color block prints, and acetate for aquatints.

Required Courses in Art Survey are required for all seniors, who must take a year of the history of art, from prehistoric to modern times. The course meets, as do the other single period courses, one period a day, five days a week. The course is taught through the slide-lecture method using the school's slides, film strips, reproductions and required museum visits. The text used is *The History of Art* by H.W. Janson, supplemented by *Art Through the Ages* by Helen Gardner. The most able students are prepared for the Advanced Placement Examination in Art History.

Single Period Electives are available in the areas of Calligraphy, Silk Screen Printing, Pen and Ink Illustration, Illustration with Colored Pencils, Portfolio Development, and Three Dimensional Design. With the anticipated move to the new building, courses in Photography will be added.

In order to qualify for a Music and Art diploma, every student must pass a state approved, three-hour comprehensive examination covering the four year study of art. In this examination, students are required to show their skill in drawing, their skill in the elective subject of their choice and their knowledge of art history, which includes a slide identification question, 50 short answers and two essay questions which are substantial, such as the way a changing social, economic, or political concept has affected an art style in some period.

All classes are enriched with field trips to the cultural resources of the city, with materials provided by high school programs of several of the museums, and with guest speakers and presentations by college representatives. Many of the guests are parents, or alumni, who are in the field of art, and who graciously consent to a one-time appearance to demonstrate a particular skill. Well-known artists who have contributed to the program over the long history of the school include William Zorach, Yasuo Kuniyoshi, Philip Evergood, Stuart Davis, Will Barnet, Chaim Gross, Paul Manship,

Raphael and Moses Soyer, Ossip Zadkine, Robert Gwathmey, Ben Shahn, and William Lescaze. Currently, a group of artist alumni is working on forming a group which will present "master classes" in the school; they include Harvey Dinnerstein, Milton Glazer, Wolf Kahn, and Daniel Schwartz. Alumnus George Lois, a noted art director (Lois, Pitts, and Gershon), is contributing his talents by handling the publicity for the opening of the new building.

A semiannual art exhibit (at the same time the Music Department presents its concert) displays the best work of the term. The entire first floor of the school, including the lobby, is turned into a gallery. The students assist with the curating and hanging of the show. In the spring exhibit, which is larger, the walls in several of the studio classrooms are used for display, with the rooms being transformed into galleries for the occasion. The Art Honor League recognizes those with outstanding records in art studies, good character ratings, and service to the schools or Art Department. New candidates, beginning with lower juniors, are installed in a special auditorium ceremony.

Group and individual murals adorn the walls of the old Music and Art, done over many years and bearing the names of the young artists, some of whom are well known in the art world today. The oldest, one in the lobby and another in the library, were done under the supervision and with the cooperation of visiting artist, Stuart Davis. Unfortunately, these will remain behind when the move is made to the new building, but then new opportunities await!

The school is supported entirely by tax levy funds in the same manner as every one of the other 101 high schools in the city. Because the budget is wholly inadequate for the specialized art program, students are expected to supply everything in the way of supplies, except for the basics. School fundraising activities supplement the meager budget; an active Parents Association assists in insuring that the poorest students who cannot afford supplies have access to them.

The department consists of 16 teachers and one chairperson, who teaches as well as supervises; all are licensed by the Board of Examiners and appointed in the usual manner by the Board of Education. It is interesting to note that five of the sixteen teachers, as well as the chairperson, are graduates of the school! Among the staff are six who are practicing artists (they maintain studios, have shows, sell their work, etc.) outside of school, and one who maintains a professional design consulting service. The latter has designed murals and layouts for Board of Education offices, and has succeeded in having several of the students employed as assistants. This staff teaches 73 art classes, using 10 studio classrooms, and one lecture hall (for the art history classes.) Classes are either a double or single period, with a period being 40 minutes long. Classes are given daily during an 18 week semester.

About 20% of the graduates go on to study in specialized post-secondary institutions such as Parsons School of Design, Pratt Institute, School of Visual Arts, Fashion Institute of Technology, Cooper Union (all in New York Ci-

ty), as well as Rhode Island School of Design (Providence, Rhode Island) and Alfred University (Philadelphia, Pa.) among many others. Almost all of the others go on to post-secondary studies in the major universities and colleges around the country. The list of graduates who have distinguished themselves in all fields is long and noteworthy. They include artists, architects, curators, designers, art directors, teachers, writers, physicians, lawyers, illustrators, scenic designers, art school directors, and admissions officers, and so on and on. A Committee of Friends and Alumni, recently formed, has collected the names of thousands of graduates who have achieved success in the arts, in professions, in business, and in technical fields, and all of whom still are enthusiastic about the unique and superior education they received at the High School of Music and Art. In recognition of the importance of the project, the Board of Education gave "seed money" to this group which is currently engaging in a fundraising effort to create an endowment fund, not only to keep itself going, but to assist the school financially.

The program at Music and Art is unique because, insofar as we can determine, it is the *only* institution in the United States to serve the gifted and talented in their own facility, instead of being provided for within a regular setting, or in a school for gifted alone. One of the advantages of the separate setting is that students are "free" to be artistic, to be gifted without being "different," that horror of the adolescent years. The three or four years of diversified, intensive "fine arts" education creates artistically literate citizens as well as artists. The association with music students in classes, recreational and social activities, and in common student activities enriches the art students culturally (as it enriches the music students because of their association with artistic peers.)

Music and Art High School is proud of producing generations of cultured citizens as well as practicing artists. That it continues to be able to do so is a tribute to New York City and its Board of Education. The completion of the new building—as part of the Lincoln Center Plan envisioned by Robert Moses, William Schuman and David Rockefeller—during this desperate period of economic and cultural retrenchment clearly bespeaks a truly brave commitment by New York City to the value and worth of the arts in the future of civilized life.

---

*Sheila Stember is the Head of the Art Department at the High School of Music and Art, New York City.*

*The High School of Music and Art is a division of the Fiorello H. LaGuardia High School of Music and the Arts.*

### References
1 Benjamin Steigman, *Accent on Talent: New York's High School of Music and Art,* Wayne State University Press, 1964.
2 "What the World Needs is More Music and Arts," *Upper and Lower Case,* International Journal of Typographers, Vol. 4, No. 2, June 1977.

# Artistically Talented Program in the Jersey City Schools

• MARGARET WEBER and ANTHONY S. GUADADIELLO •

Located in the New York metropolitan area, Jersey City Public Schools serve a primarily low socioeconomic, minority population through five high schools and thirty elementary schools. Jersey City's program of artistically talented classes (ATC) grew from a desire to reach children showing the greatest potential in the visual arts. We faced problems. On the one hand, an insufficient faculty/student ratio had crippled our efforts to create a sequential, K-12 art program for the whole city. Of some 32,000 students, less than 40% in elementary and 15% in high school were instructed by our 32 art teachers. On the other hand, we needed a means of implementing our commitment to grouping artistically gifted children. Perhaps most important, we wanted to give our students an equal opportunity to successfully compete in art schools, colleges, and the art world in general.

Despite Jersey City's proximity to Manhattan's rich cultural resources (and despite growth of local museums), our students have not known the museums as welcoming "public libraries" for the study and enjoyment of art. The energy required for daily survival among welfare and working class families, leaves decreasing time for parents to spend with their children. In fact, as the numbers of a single head of household and two family breadwinner families grow, this issue is a problem which increasingly cuts across class lines. In a context where parents have not introduced their children to the neighborhood library, museums seem rather distant institutions.

What concept of daily life of an artist would such a child (even a gifted and motivated child) hold? Would a child from this background recognize his/her gifts as potential career directions? Clearly the skills (technical and conceptual) and self-confidence we envisioned helping our students acquire, would require many different kinds of experiences to develop. Would a Gifted/Talented program permit us to offer the needed experiences? The time was right to try.

This need within our school system was matched by growing national interest and a new state mandate. In 1978 the Jersey City Board of Education recommended that innovative programs for the gifted and talented be developed. By June 1979 the Jersey City Public Schools had identified those elementary children with the greatest academic potential. Special classes for them were formed in eight magnet locations for 1979-1980. The art department designed an art curriculum for these academically gifted students by working closely with their instructors. Through this interdisciplinary venture we gained the necessary experiences and the school district's support

*Art teacher Margaret Stokes and students with tempera paintings of views of the classroom.*

for an independent art program for the visually gifted and talented.

In September 1980 artistically talented classes (ATC) were formed at each of the eight magnet sites; the High Schools for the Visual Arts also opened. September 1981 marked ATC's expansion to 27 of our 30 elementary schools. In September 1982 music was added to the renamed Jersey City High School for the Visual and Performing Arts. Begun in January 1983, a program of creative arts on Saturday for the talented (CAST) includes dance students as well.

With this institutional *breadth* achieved in three years, the art department was able to better identify talented children and to begin providing them the necessary *depth* of artistic experience. The goals for the three stages of ATC are the following:

1. To aid each student in the realization of his/her gifts and self-worth;
2. To broaden each student's understanding and application of art forms and their role in our culture;
3. To foster positive interaction among students of differing ethnic, racial, and/or class backgrounds; and
4. To help each student understand the connection between his/her skills and potential contribution to society.

For the purpose of clarity our programs will be described in three components.

**Elementary Artistically Talented Classes**
Kindergarten through fourth grades and fifth through eighth grades are the two levels of the first stage. Screening of elementary students involves nomina-

tion and reference forms, in-house drawing tests, and the Torrence Test for Creative Thinking,© Figural Booklet B. A maximum of fifteen students on each level within each school are taught by one of the art instructors in the participating schools. In addition to regular art class, designated students are excused from their other classes once a week for between 45 minutes and two hours of ATC instruction, depending on their availability and interest.

Lower elementary students follow sequential lessons concentrating on the basic elements and principles of art. We give them an opportunity to use these elements in their own creative expressions. For example, "experience sheets" (see Figure 1) guide students who work on their own, in a group, or with the class. These sheets include the definition of a concept and a related problem to solve; art prints are listed for reference. The students may also substitute a problem of their own.

Upper elementary students in ATC are exposed to a more varied curriculum which prepares them for entry to the high school program. They study in a relaxed atmosphere; to diversify their experience, field trips are stressed.

On one such occasion, students were concerned with the differences between rural and urban environments. They were prepared in class with lessons in drawing, painting, and composition. Slides and artists' prints of rural and urban settings were used in lectures and discussions. In a variety of media,

---

**Figure 1**

Experience Concept: Texture
**Definition:** Texture is the way things feel. Things can be hard, soft, fuzzy, smooth.
**Statement:** Artists use texture to make their work more interesting. Texture can be either:
   *Actual*—The artist paints or glues objects to the picture's surface—
   *Simulated*—The artist's drawing or painting makes the texture look as if it were real; like painting hair to look like hair—or
   *Invented*—The artists use paints and pencils to make patterns which look like they have texture, but not like any real textures.
   Look around you—inside and outside. How can you make these textures?
**Art Prints:** Look at the following paintings to see how these artists have used texture.
   Millet: *"The Gleaners"* (1857)
   Chagall: *"The Musician"* (1912-1913)
   Rousseau: *"Portrait of Joseph Brunner"* (1909)
   Da Vinci: *"Mona Lisa"* (about 1502)
**Problem:**
   1. Make a chart with different textures; name them.
   2. Invent an animal with these textures or use them in a drawing of yourself or a friend.
**Substitution:** (If you have other ideas about texture, you may talk to your teacher about what you can do with them.)

Limestone Statue of a Votary, artist unknown. 470-440 b.c.

The Greeks learned how to make large statues from the older peoples of the Mediterranean, especially the Egyptians. The difference, though, is in the fact that the Greeks left space between the arms and torso.
1. Line is very important in sculpture as well as in drawing. How did the artist use it?
2. How did the artist use line in the face?
3. How does this figure compare in size to people you know?
4. How did the artist use the clothing in this sculpture? Can you tell the climate by the way he is dressed?

**Figure 2A**

including photography, the students created studies of a country place and their own neighborhood. They compared visual forms in both environments by designing two compositions in similar media.

Not only were our inner city students amazed by the varied geography of New Jersey, but they were able to translate the excitement of running through fields into their studies of landscapes. They were also awakened to the forms of their own neighborhood: they saw contrasts *and* similarities to the shapes of country life. Their final compositions revealed a new visual literacy.

Children of both elementary levels take field trips to galleries and museums. Our staff designed a guide book to the Metropolitan Museum of Art. Entitled "Changes . . . an arm is a leg? . . . Why are those fingers so long?," it makes students "Stop, Look, and Observe" on their path through art and history, at the end of which they construct "a Person" with materials of their choice. (see Figures 2A, 2B, 2C).

Since the transformations of the body in art history are a function of logic and fancy, our questions and exercises were designed to demonstrate that art is a discipline of the two, a discipline that the children practice with sketches, plans, and models. Our guide is one example of how they proceed from concepts to applications. Learning to see, experiencing creative problem solving, and working with different media prepare the students for future studies in high schools.

**High School for the Visual and Performing Arts**
The high school program is open to all eighth grade public (and private) school students by examination and interview. About 35 visual arts students are accepted each year. Those who apply unsuccessfully the first time may be admitted to an auxiliary program in each of the five high schools, after a year of which they can reapply to the school. In the spring of the previous year, at orientation, incoming students and their parents are introduced to the teachers, administrators, advisory and parents' council members, and other community supporters of the program at Ferris High School where this magnet program is currently located.

The staff of the High School for the Visual and Performing Arts includes three full-time art instructors (a fourth will be added next year to accommodate our first senior class), one part-time photography teacher, and a coordinator.

Visual arts students are grouped together for homeroom. Freshmen receive two periods of enriched ATC art classes (ATC I) per day. Sophomores, juniors, and seniors can take between 10 and 15 credits of artistically talented classes per year, according to individual needs and career orientation. Maximum class size is eighteen.

Teacher rotation during the year ensures student exposure to the different disciplines and areas of expertise the faculty offers. For example, our junior classes are taught by both a fine and a commercial instructor.

The four objectives of the high school curriculum are to reinforce the students' understanding of art elements and principles introduced in elementary school, to increase their ability to apply these concepts using diverse media, to improve technique and their use of technology to enhance their compositions, and to familiarize students with the requirements of different careers in art.

In one series of media manipulations, students learned how one compositional idea could be developed in various forms. They began by examining cityscape as a genre, focusing on the geometry and perspective of architectural settings. Discussions followed on focal point, contrast, and composition in photography in preparation for a photographic field trip to an architecturally interesting local neighborhood. After the trip the students did value studies of one of their black and white photographs. Using economy and simplification, they drew only the basic shapes without detail.

With a Goodkin Type C projector, the students traced their drawings to create stencils for paper collages. Using this stencil to create other paper shapes allowed the students to focus on the way negative and positive shapes create shape in photography, drawing, and printing. Through their earlier study they learned how value changes create form. Limited to two colors in the next step (the collage), they discovered how value changes create form in color as well.

Next they used the same composition and their understanding of the con-

---

**Figure 2B**

Bust of Philip II of Spain. Workshop of Leone Leoni. Italian, Milan, 1509-1590.

1. What do you think of the way this man is dressed? How does this compare with the last sculpture you saw?
2. What does his expression say?
3. What is this type of sculpture called?
4. This sculpture was carved from marble. How long do you think it took the artist to do it? Would you like to do one like it?

cept of positive-negative, to create linoleum prints. The precision acquired in cutting their stencils led to precision in cutting their linoleum blocks. They progressed from 1 color to 2 color prints. Freed of compositional problems, students explored this medium. Some students developed multiples based on grids, and others became involved in multi-media compositions.

This example is typical of our structured curricular approach. Our curriculum is process rather than project oriented. The sequential lessons integrate concepts, media, technique, and art history into steps which help students use skills acquired through one experience at a higher level in the next.

Exposure to the art world is accomplished through field trips to museums, galleries, architectural sites, artists studios, and commercial art establishments, and by working directly with artists through our mentorship, Artist in Education, and internship programs. The Mentorship programs, for instance, allow selected students the opportunity to work in very small groups with a professional in an art area they are considering as a career. Meeting the students after school and weekends, the artist shows them how and where he or she works. The students learn basic concepts about their mentor's field by participating in his or her ongoing projects. They are given

---

**Figure 2C**

Summary: You have studied the human form in class and at the museum. Now you have seen the manner in which other artists have rendered people. We are now going to ask you to construct a person. You may use whatever materials you desire. You must first make several sketches and describe in writing what you are going to do and why. If you plan to change the human form in any way, be sure to explain your reasons. Try to be logical in both your drawings and your explanations. One suggestion is to create a person of the future. You must name the year and describe his environment. Then go on to describe what he will look like and if any changes have taken place. Start collecting materials you will need to make this form. Here are some ideas and questions to think about:

—How big will you make him/her . . . 3 feet? 8 feet?

—How big will you make the form . . . Like the human skeleton? Of wood? Wire?

—Where can you get free materials to work with your project? In the garbage? Old scraps?

—What will you use for eyes?

—Will you let part of the inside show?

—What changes will you make? Why?

Start sketching ideas now. Bring your sketches to the next art class and discuss your plans with your teacher and art specialist.

Remember . . . Have Fun!

The finished figures will travel around the state on exhibit. *Think hard; be different; be creative!*

related assignments by their mentors which increase their in-school portfolio preparation. This work also contributes to ongoing exhibits and student publications.

The high school also utilizes the community art resources available in Jersey City, including art workshops and internships at the Jersey City Museum, and at the C.A.S.E. Museum of Contemporary Art in Exile. Other community resources include the members of our advisory council. Composed of representatives of local arts organizations, and education institutions, as well as parents, teachers, and administrators, our advisory council supports the program and assists in addressing our problems. Currently this body is focusing on the need for more space to house our growing program.

**Creative Arts on Saturday for the Talented (CAST)**

A project of the Creative Arts on Saturday for the Talented (CAST) began in January 1983 for students who are CAST screened or were previously admitted to ATC in grades six through twelve. Professional artists and art school students from the metropolitan area teach 21 courses, including crafts, commercial art, graphics, fine arts, photography, fashion design, and portfolio preparation.

The program consists of three semesters per year with seven courses each semester. Each course runs for six consecutive Saturdays. Each Saturday the student may attend one or two courses. Class size is limited to ten students per session. There are field trips in the middle of each semester and a fourth at the end of the year for students enrolled in any semester.

By the end of each course, students will have encountered enough media, methods, and materials to complete at least one project. Three pieces of work

71

by students in each course will be exhibited at a local museum or gallery, with a slide presentation at the opening of the show.

Exposure and mobility are the major goals of CAST: exposure to parts of our state, to small instructional groups, and especially to artistic subjects of interest. The program gives students the opportunity to leave their neighborhoods to interact and to learn with like-minded students in another area of the city. We hope those who attend CAST will be more willing to attend our High School for the Visual and Performing Arts located outside their neighborhood.

In the same way that our curriculum takes students step by step toward a goal, Jersey City's ATC program is growing incrementally. Though charged with accusations of elitism, we have witnessed the vindication of our conviction that "skimming" the most talented would create the rising of "new cream." Those who initially feared that this program was created at the expense of the regular kindergarten through 12th grade art classes now enthusiastically support it.

We use our slide/tape shows and color brochures to advocate, not just for our gifted program but for all arts programs, before local community groups, boards of education, and state and national organizations. An indication of the success of this advocacy is the fact that ATC is fully funded locally by our board of education, including funding for a permanent student art collection. (Supplementary activities such as Mentorship and Artist in Education Programs are supported by state grants.) Another indication of our success is reflected in the invitation we have received to show the work of ATC high school students at the State Museum in Trenton during the 1983-84 school year.

We continue to believe that through informed exposure we can move our students to new levels of educational mobility. When students are aware of their options, have the self-confidence to strive toward achievement, and have acquired the skills needed to move toward desired goals, they *will* be able to make positive post-secondary life choices. This, after all, is the purpose of public education.

With our first senior class entering the High School for Visual and Performing Arts in September 1983, we will begin collecting the necessary data to evaluate our efforts. It will take a few more years before we can chart our students' progress in post-secondary schools and in their careers. For now it is most exciting to see students enjoying, working, and learning the arts together in classes, museums, fields, and streets on weekdays and weekends.

---

*Margaret Weber is Visual Arts Coordinator, Jersey City High School for the Visual and Performing Arts, Jersey City, New Jersey.*

*Anthony S. Guadadiello is Supervisor of Art Education, Jersey City Public Schools, and Instructor, Art Education, Jersey City State College.*

• SECTION TWO •

# State and
# National
# Programs

# The Indiana University Summer Arts Institute

• GILBERT CLARK and ENID ZIMMERMAN •

The Indiana University Summer Arts Institute is designed to provide unique learning opportunities for students in the sixth through ninth grades who are seriously interested in studying the visual arts, along with music, dance, and drama. For two weeks, during mid-summer, 60 I.U. Summer Arts Institute participants from throughout the state of Indiana, either live in a dormitory or commute to the Indiana University campus. The program provides many opportunities to explore and expand participants' talents and abilities in a university environment. In addition to attending visual arts, music, dance and drama classes, participants are offered recreational activities and evening programs designed for their particular interests and needs. This is an unusual program in the arts because participants study the arts as separate and distinct disciplines and not as subsidiary parts of an academic or humanities program.

**Goals of the Program**
Principal goals of the I.U. Summer Arts Institute are to extend skills and understandings about particular aspects of the visual arts and music, dance, and drama and to provide opportunities for participants to interact with others, with similar talents, as well as with professionals in the arts. In this program, visual arts, music, dance, and drama are studied to enable participants to understand and appreciate feelings, ideas, and values communicated in each of the major art traditions and to develop skills of expression in these arts. Participants also have opportunities to explore the university campus and experience arts facilities that exist as part of the university environment.

**A Structure for Learning Experiences in the Visual Arts**
Curricula for intellectually gifted students often stress advanced conceptions and sophisticated ideas. Students who are gifted in science, mathematics, social studies, and language arts are often offered accelerated or enrichment programs that are adaptations from regular school curricula. Learning in the visual arts, for students who are artistically talented, also requires curricula that stress advanced understanding, knowledge, and skills about the visual arts. Curricula in the visual arts, however, are not usually structured as they are in other subject matters. To accelerate and enrich knowledge, understanding, and skills in the visual arts is therefore, more difficult.

The activities of professionals working in the areas of art history, aesthetics,

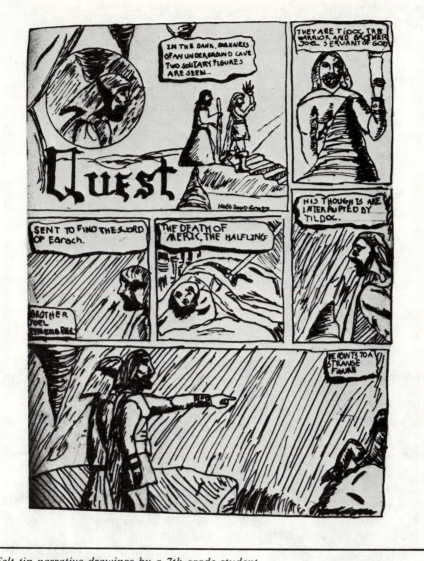

*Felt tip narrative drawings by a 7th grade student.*

art criticism, and art production suggest appropriate learning experiences for art students (Clark and Zimmerman, 1978a, 1978b, 1981). This idea is not new; science, music, mathematics, and other disciplines have long taught advanced students to understand and emulate the work of adult professionals in these fields. Students study what practitioners in art production, art criticism, art history, and aesthetics actually do.

Artistically talented art students should know and experience each of the

*Acrylic still-life painting by a 7th grade student.*

four roles: artist, art critic, art historian, and aesthetician, with full acknowledgement of each separate professional role. Visual arts education programs should develop their character specifically from recognition of differences among these roles, clarification of role differences when assumed by the learner, and full recognition of the contribution of each role toward a holistic

76

art education. From this basic construct, it is possible to identify and define content for learning experiences that are appropriate to each role, while maintaining an awareness that each role is an integral part of the complex and unique subject matter of art.

## Program Organization

Organization of the I.U. Summer Arts Institute has evolved through the sponsorship of several Indiana University agencies: Office of Summer Sessions, School of Education (Department of Art Education), School of Fine Arts, School of Music (Department of Music Education), and School of Health, Physical Education, and Recreation (Departments of Modern Dance and Recreation). Faculty and staff representatives from these agencies meet throughout the academic year to plan courses, teaching methods, and recreational and enrichment activities that are appropriate to the needs and interests of students with superior abilities in the arts.

There is an institute director and a general coordinator. These and other art education faculty coordinate the arts programs. Other faculty of the institute are drawn from the local art community and from the faculty of Indiana University. The arts faculty is composed of local artists, fine arts, music, art education, and dance instructors, and graduate students in these departments. Local and nationally known guest speakers and performers also participate in Summer Arts Institute programs and activities.

Residence and recreation aspects of the program are supervised by a separate staff. A residence hall director is responsible for dormitory supervision. An activities director is responsible for recreation activities and special programs and acts as head counselor. Counselors are selected on the basis of their arts background and their past experience in working with children in educational settings. These counselors supervise recreation activities, bring participants to activities and classes, and live in the dormitory with resident participants. There is one counselor responsible for every ten participants.

## Criteria of Selection

Participants must meet at least three of the following criteria to be selected for the program: (1) high interest in one or several of the arts, (2) past experience in one or serveral of the visual arts, (3) high motivation and self-confidence in one or several of the visual arts, (4) achievement tests scores at least two grades higher than the student's present grade, (5) measured, above-average intelligence, (6) or placement in a local gifted and talented school program. Students must be nominated by two or more of the following persons: a principal, counselor, arts specialist, or teacher to participate in the I.U. Summer Arts Institute.

## Program Description

I.U. Summer Arts Institute participants select a visual arts major in fine arts *or* computer graphics and elective classes in visual arts, music, dance, or drama. Major classes are offered in the mornings; elective classes are of-

fered in the early afternoon. In fine arts major classes, drawing, painting, and sculpture, students learn basic media techniques and skills of expression. Still lives, models, and outdoor scenes provide observational bases for expressive fine arts learning activities. Slides and reproductions of art works are used to motivate and enrich students' experiences in most class meetings. Classes such as *Sagas and Pencils*, creating visual narratives; *Drawing with the Mind's Eye*, exploring a variety of drawing media; *Coloring Your World*, learning to use watercolor and acrylic paints; *Paint!* exploring acrylic painting techniques; and *Creating 3-D Forms*, using clay to create small sculpture; are offered as choices within the fine arts major. Computer graphics major classes stress basic programming and the generation of original graphic images. Participants work on mini-computers and explore main-frame computer graphics facilities at the university. They also have the opportunity to see computer graphic art work created by students and professionals.

Afternoon elective classes offer opportunities for participants to select areas of interest in a variety of other art activities. Participants select two electives that meet on alternate afternoons. Classes in printmaking, batik, photography, ceramics, choral singing, electronic music, music appreciation, jazz dance, modern dance, musical theatre, and improvisational theatre have been offered in the past. Organized recreational activities, in the later afternoons and weekend, include swimming, games, sports, leisure activities, open art studios, and practice labs. Special evening programs range from museum visits, musical events, films, guest artists and lecturers, an arts "Knowledge Bowl," a talent show, and extra art workshops, to a Saturday night dance. Many of these evening activities involve local arts groups that encourage active student participation.

The I.U. Summer Arts Institute program is unique in a number of ways. It is designed specifically for upper elementary and junior high school students, ages 11 to 14. In this program, students can study in more traditional fine art classes or in classes using newer computer graphic technology. It is important for students in this age group to study the visual arts from a variety of points of view. Highly talented students should become aware, at an early age, of their abilities and be able to make educational and career choices appropriate to their talents.

Because the I.U. Summer Arts Institute is offered as a residential program on a university campus, the libraries, museums, exhibition facilities, fine arts classrooms and equipment, musical and theatrical facilities, and other university arts resources offer students a variety of unusual educational opportunities. The majority of I.U. Summer Arts Institute participants come from rural communities throughout Indiana; most of them do not have local access to such arts resources.

Participants who have been identified as having potential for superior abilities in the visual arts have opportunities to study in small groups with professional artists, to interact with students who share similar interests and abilities, and to learn to use media to develop skills, knowledge, and understandings about specific aspects of the arts. Along with studying the visual

arts, participants also elect music, dance, and drama activities that enrich their study of the visual arts and help develop their talents and interests in several modes of expression.

## Program Support
The I.U. Summer Arts Institute is supported by the Indiana University Office of Summer Sessions and participants' tuition. The Office of Summer Sessions provides salaries for the director and coordinator and honoraria for guest artists and speakers. Participants pay a tuition fee that is sometimes underwritten by local organizations within their communities. Churches, schools, sororities, and other service organizations have provided full or partial tuition for many participants. A limited number of partial scholarships are also awarded, each summer, through the I.U. Summer Arts Institute. A $380.00 fee, per student, covers the costs of instruction, materials, recreation, housing and meals, counselors, and access to university resources. Participants who can commute have the option of a non-residential $200.00 tuition fee. The entire cost for operating the Institute was approximately $25,000.00 in 1982. Further support for this program is offered by free access to the facilities of the Department of Art Education and the School of Education at Indiana University. In addition, teachers, administrators, parents, and university students, who are interested in studying and working with students who are gifted and talented in the arts are offered a three-credit course and a related three-credit hour practicum. The course examines characteristics, means of identification, and teaching strategies for students with superior abilities in the arts along with discussion of relevant and timely issues in the education of talented students. Persons enrolled in the related practicum serve as teacher aids as part of their class experience and help make possible the low ratio, about 4 to 1, of participants to teachers and staff.

## Research and Evaluation
Indiana University doctoral students and faculty study participants' behaviors in art making and art perception, cognitive styles, personality factors, and drawing abilities to gain further understanding of these processes and of characteristics of talented students in the arts. A funded research is underway to study the social and educational effects of labeling students as talented in the arts. In 1983, participants will help develop and evaluate museum exhibit materials as part of an NEH funded development grant.

Teachers, staff members, participants, and practicum students are required to fill out evaluation forms at the end of the I.U. Summer Arts Institute. Approximately four weeks after the participants return home, an evaluation form is mailed to parents asking them to react to their child's summer arts experience. All evaluation forms request information about which program activities were favored and why and what program changes are suggested for the following year. These evaluations are carefully studied to guide changes and adjustments in the following year's Summer Arts Institute.

Parents' comments indicate that their children enjoyed the experience, made

many friends, learned new art skills, and in most instances, look forward to returning the next summer. Representative parent comments were: "She was very reluctant to come home at the end of the camp," "My son really enjoyed the opportunity to do graphics on the computer," "She emphasized how friendly the other children were," "Classes were small, and my daughter could spend a lot of time on one project," and "We were lucky to have such an opportunity for our child." One Summer Arts Institute participant wrote: "I paid half myself and gave up all other summer activities to come, and it was worth every cent." Approximately 25-30% of each summer's participants return each year. This indicates, as do the evaluation comments, an extremely positive reaction to each summer's program.

---

*Gilbert Clark is Chairperson, Art Education, and Director of the Summer Arts Institute, Indiana University, Bloomington, Indiana.*

*Enid Zimmerman is Assistant Professor, Art Education, and Coordinator of the Summer Arts Institute, Indiana University, Bloomington, Indiana.*

### References

G. Clark and E. Zimmerman, "A Walk in the Right Direction: A Model for Visual Arts Education, *Studies in Art Education*, 1978a, Vol. 19, No. 2, pp. 34-49.

G. Clark and E. Zimmerman, *Art/Design: Communicating Visually*, Blauvelt, N.Y.: Art Education, Inc., 1978b.

G. Clark and E. Zimmerman, "Toward a Discipline of Art Education," *Phi Delta Kappan*, 1981, Vol. 63, No. 1, pp. 53-55.

# Oklahoma's Unique Fine Arts Camp

## • JANE NELSON •

It's been called a bootcamp for budding artists. The Oklahoma Summer Arts Institute lives up to that reputation in many ways: rigorous training is required along with dedication, talent, motivation, and a healthy dose of dreams.

Nestled in the austere granite hills of Quartz Mountain State Park in southwestern Oklahoma, the Oklahoma Summer Arts Institute every year brings 200 talented teenagers together with acclaimed professional artists in a multi-faceted fine arts camp. The stark hills, which border a small, serene lake, encircle the Quartz Mountain lodge, cabins, and grounds to provide a secluded, primitive, and inspiring setting for the program. For two weeks every summer, there is music, dancing, poetry being read, lines rehearsed, and easels littering granite boulders. The students, aged 14 to 18, put in long hours rehearsing, practising, and trying again. And still they beg for more. They had to work hard just to get here; more than 600 young hopefuls compete in statewide auditions for the 200 coveted spots.

"The students are like enormous sponges," said guest conductor Judith Somogi, conductor of the Frankfurt (Germany) Opera. "They absorb everything."

The students experience, usually for the first time in their young lives, total immersion into the arts. "All day, every day, they live and breathe the arts in classes and seminars. This intensity allows the student to completely focus his energies, and the result is rapid improvement and development," explained former printmaking instructor Daniel Kiacz, master printer and assistant professor of fine arts at the University of Oklahoma. "What diversions there are, are creative in nature. They don't detract from the stimulation of ideas."

### Curriculum and Cross-Pollination in the Arts

Students study in one of nine disciplines: orchestra, ballet, modern dance, painting, printmaking, photography, creative writing, mime, and acting. Classes and rehearsals are required morning, afternoon, and some evenings. Lodge rooms are converted into classrooms; an indoor swimming pool is covered by a special flooring to become rehearsal space for ballet and orchestra students; outdoors, pink and yellow-striped circus tents become mime theaters and painter's studios, and brightly-colored banners dance in the gentle lake breezes.

Evening seminars, called "Conversation With The Artist," offer a roomful of inquiring teenagers the professional insights and personal reflections of visiting artists and the resident faculty. This past summer, the guest artist program was expanded to include nine top-notch arts professionals including

actress Jane Alexander; Chicago sculptor Richard Hunt; and Gabor Rejto, Hungarian-born cellist who studied under Pablo Casals and is director of the string program at the University of Southern California. Guest artists in previous years have included acclaimed American artist Fritz Scholder; Russian ballerina Irina Baronova; and pianist Israela Margarlit.

The resident faculty also offers artistic insights in evening interdisciplinary sessions. The Institute faculty ranks as one of the finest assembled in the country and reads like a "Who's Who in American Art Today." Instructors have included conductors Judith Somogi and Pulitzer Prize-winning composer Karel Husa; poets William Stafford and Donald Hall; ballet luminaries Maria Tallchief, director, Chicago City Ballet, and Rosella Hightower, director, Paris Opera Ballet; and Bert Houle, co-director of the Houle-Wibaux Mime Company in San Fransicso.

Arriving at Quartz Mountain from around the world, first-time instructors often don't know exactly what to expect from their young students. Photography instructor Richard Ross arrived from the University of California at Santa Barbara with Instamatics and toy cameras for his class; the students brought fancy "high-tech" equipment in molded aluminum cases. After 15 days at camp, the teacher and his students had had a profound effect on the other. "I didn't expect the students to be so good," Ross said. "I thought camp in Oklahoma would be just that and no more. Instead, I found the students' attitudes about learning superior to any class I have taught. Once ideas are presented to them, it is like opening a dam."

While receiving a massive infusion of intensive arts training, appreciation, and interdisciplinary exposure, students also get a taste of innovative, challenging teaching methods. Writing instructor Jane Shore, poet and assistant professor of English at Tufts University, Medford, Massachusetts, gives her students many of the same assignments she gives her college classes. "They do work here that is equal to or better than some of my graduate students. I don't talk down to them. There's no pussy-footing around. We don't coddle them, and they get the honest criticism they need," she said.

In the photography class, Ross designed an exercise for his students to make a clean break with preconceptions. Students were asked to make a list of familiar images to photograph, and most of the lists included sunsets, barns, and barbed wire fences with windmills in the background. "Every item on those lists was labeled a cliché," Ross said, "and become forbidden photographic subjects." To cure any lingering allegiance to "sunset photography," Ross took his students on a pre-dawn hike into the mountains to watch the sun rise—and no cameras were allowed. "After years of photographing sunrises, the students were able to look at the sunrise without feeling the world would be poorer without 13 new photographs from that— though striking—vantage point," he said.

The classes are kept small—about 15 students per class—to keep interaction optimal between the artist/instructor. The challenge in the classroom is often a two-way street, as one of last summer's guest conductors found

*Creative writing outdoors; Pam Richardson.*

out. "Every time I go in front of those kids, they're challenging me, asking me why. They want more every day," observed conductor David Becker, virtuoso violinist and conductor-in-residence at the University of Miami. "There can be apathy among professionals who've gotten to the top and feel like they no longer need to prove themselves. That's why I love these kids, and I think all of the instructors that are brought here have that same attitude," Becker said.

## Created to Fill a Need

The Oklahoma Summer Arts Institute was founded five years ago. Parents and educators appealed to the State Arts Council of Oklahoma for an intermediate step between high school arts curriculum and advanced professional training for Oklahoma's talented teens. A committee of artists and educators shaped the program, and the first Institute appeared in 1977 as a weekend experiment in a northeastern Oklahoma church campgrounds. The experiment proved so successful, the Institute moved to Quartz Mountain in 1978 and was expanded to a two-week program.

83

In the ensuing years, some areas of instruction have changed very little; others have evolved extensively—depending on the result of in-depth, post-camp evaluations by students, faculty, and the small administrative staff. Certainly the Institute has grown financially—from the $5,000 "seed" money donated the first year by the State Arts Council to an estimated half-million dollar budget this year. Although the program is endorsed and supported by several state agencies, the major financial support for the non-profit corporation comes from individual, foundation, and corporate donations. Tuition is $400, about one-third the amount it actually costs for each student. The Institute's annual fund-raising campaign endeavors to secure necessary financial support to insure continuing top-quality educational and artistic advantages for its talented students. Once a student passes the rigorous auditions, he will not be turned away due to a lack of funds; scholarships are available on the basis of financial need. And college credit is offered through the College of Fine Arts, University of Oklahoma.

**Statewide Effects**
More and more students and teachers across Oklahoma are becoming aware of the quality arts education offered at Quartz Mountain. Students who have participated in the unique camp bring back many benefits to their home schools and towns, as artists, individuals, and advocates.

"While we at the Institute try to provide a springboard for a professional career in the arts, the education of every student is our primary objective," said Mary Frates, OSAI director. "Whether a student chooses to pursue a career in the arts is not the point. It does not matter if a silkscreen printer becomes an engineer, a poet becomes a physician, or an actor turns lawyer. The seed of cultural enrichment has been planted and will blossom within that student wherever he goes, whatever he does," she said.

The intensive training at camp produces dramatic results. On the final weekend of camp, all students exhibit or perform their work. "It's amazing, but these are the same students who arrived only days ago, uncertain and afraid. Now they look like young professionals. They are transformed. Believe me, that is magic," Frates said.

"Every year the students prove once again the ideals which embody the spirit of Quartz Mountain: dedication, discipline, and an incredible inspiration that each one of them carries back home," Frates said. "They bring with them the trust, willingness, and openness to life that—combined with the artist's love for his work—makes the Institute a place of special magic for two weeks, year after year."

The success of OSAI has spawned similar programs for younger students in Tulsa, Altus, and Bartlesville, Oklahoma, junior high schools. The local programs are "day camps" and strive to provide the best possible professional art instruction. And a student mime company has been formed at a Lawton, Oklahoma, high school as a direct result of OSAI influence and popularity.

The Institute also publishes student writing in a state-circulated anthology.

*Mike Kemper working on a print. Photo credit: David Fitzgerald.*

The best efforts of visual arts students are promoted in an exhibit, called "Images from Quartz Mountain," which the Institute circulates throughout the state during the year free of charge.

The Institute staff is constantly developing programs to serve the needs and requests of the state. When it became evident that many adults wanted the same kind of high quality, in-state arts training, the Institute began plan-

ning three-day adult workshops to be held at Quartz Mountain in the autumn. A pilot workshop in orchestra was launched this fall. OSAI music coordinator Legh Burns, who is conductor of the University of Oklahoma Symphony Orchestra, conducted the small orchestra of 50 adults in a repertoire of standard orchestra classics. The culmination of the workshop was an evening performance in the woodsy glen of the Quartz Mountain amphitheatre highlighted by guest soloist Pierre d'Archambeau, world-renowned violinist who has presented concerts in Carnegie Hall and in music halls around the world. Two workshops are planned for next year, one in visual arts and the other in drama. "Every year we receive inquiries from teachers about attending the summer Institute. We hope these autumn workshops will, for example, give art teachers a chance to explore serigraphy and monotypes—areas some art teachers have not studied themselves, but their students learn about at camp," Frates said.

## National Outreach

"Quartz Mountain Magic"—as most students and instructors call it—is available to students across the country through documentary films. Two award-winning educational films, produced by the Institute, are designed to encourage students to continue their studies in the arts. The films show students working with professional artists, and take the viewer backstage into the world of professionals. The films stress that success in any career requires talent, hard work, sacrifice, tenacious dedication, and a strong belief in oneself. Films now available include "Onstage with Judith Somogi," featuring the New York City Opera and Frankfurt Opera conductor, and "Onstage at Quartz Mountain," a 20-minute documentary about OSAI. The Institute's latest film production is "Fritz Scholder: An American Portrait," which premiered in October in New York. In the film, Scholder's life as an artist and his philosophies are explored. A national television airing by the Public Broadcasting System is anticipated. The Institute is also producing two other documentaries, "A Gift, A Talent and More" and "Theatre Beyond Words: The Art of Mime." The films are available on a free loan to educational institutions.

## Professional Preview

Attending the Institute may spark a professional career in the arts. One of the Institute's first students to turn professional is Robert Underwood, a Tulsa, Oklahoma, student who studied ballet at Quartz Mountain for several summers. Two summers ago, Georgina Parkinson, a ballet mistress for the American Ballet Theatre in New York, critiqued Underwood's abilities while teaching at Quartz Mountain, and she recommended Underwood to ABT director Mikhail Baryshnikov. Underwood was called for an audition; he is now dancing his second season with the ABT.

Although student successes can be storybook, some OSAI students ultimately choose careers outside the arts. "The idea is, give our talented

kids a shot, let them know what is possible. The rest is up to them," Frates said.

Nina Morishige showed signs of becoming a very gifted musician during her orchestral studies at Quartz Mountain. But Nina ultimately chose to pursue math instead of music. This year she received her master's degree from Johns Hopkins, at the tender age of 18, and was selected for a Rhodes Scholarship!

Each year several former OSAI students help defray college costs with scholarships awarded through the National Arts Recognition and Talent Search (ARTS), administered by the Educational Testing Service, Princeton, N.J. The Institute encourages its former students to apply for ARTS by mailing scholarship applications to their homes. This year, one Oklahoma student won a $3,000 scholarship as an ARTS finalist, and four semi-finalists from Oklahoma received $1,500 scholarships. All of the Oklahoma ARTS winners are former OSAI students.

Amy Wilson, a former student of the Institute from Ardmore, Oklahoma, now studying writing at Bennington College in Vermont, was an ARTS semi-finalist two years ago. "OSAI is not just a summer camp. You work hard. Sometimes it's frustrating and tedious work, but you have to be able to accept frustration. I give the Oklahoma Summer Arts Institute credit for teaching me a great deal about my craft and greater credit for teaching me about myself. But, you're the only one who knows if you can make it as a professional in the art world."

---

*Jane Nelson is Public Information Coordinator for the Oklahoma Summer Arts Institute, Oklahoma City, Oklahoma.*

# Seeking the Best: Georgia Governor's Honors Program, Visual Arts

## • RUTH GASSETT •

On a June morning in Valdosta, Georgia, eighteen students are producing art. The instructor is challenging each student to investigate how the elements and principles of design are used in creating expressive form. Later the students study in-depth the problems and challenges that confront the artist. Conversations with visiting artists and other students, field trips to artists' studios, exhibits, and art production fill their day with intellectual and social discoveries. Each will return home with a better understanding of art and artists. These students are participating in the Georgia Governor's Honors Program (GHP), a school with a tradition of excellence.

Summer vacation, family, cars, comforts of home, and lifelong friends are replaced by classes for six weeks. Since 1964, students choose to attend the summer residential program for gifted and talented public or private high school students in Georgia. When asked their reasons, art students respond, "to learn more about being an artist" . . . "the opportunity to meet and work with students my age" . . . "to study with a top teacher." Why would a student make this choice? Simple—the Governor's Honors Program has such as a high degree of credibility that students are honored by their teachers' nominations. Students selected to attend eagerly await the campuses' opening.

Six hundred students who have completed the tenth or eleventh grade become Governor's Honors Program finalists through a cooperative effort of local school system personnel and statewide committees. Students who show unusual talent, aptitude, or ability are nominated by local teachers to apply in one of the instructional areas, i.e., English, music, visual arts, science, dance, foreign language, drama, mathematics, social studies, or vocational education. The nominee quota for each school is in proportion to that system's enrollment as measured by average daily attendance.

A visual art student's application includes teacher recommendations, student comments, transcript of grades, and other data about the student's qualifications. After reviewing all applications, a screening committee of art professionals interviews each student. For the interview each student prepares a portfolio of original art in two and three dimensions. Approximately 120 students are interviewed each February. The art professionals base their final decisions upon commitment toward learning; high achievement as evidenced by imagination and creative artworks; ability to work independently; ability to pursue in-depth study; original thinking; and critical response to artworks.

Competition is keen, and anxiety runs high, since only one in four nominees will ultimately be accepted into the program.

The challenge of teaching in the Governor's Honors Program is met by talented, sensitive, and hardworking art teachers. The teachers are nominated by the art curriculum consultant from the Georgia Department of Education. Most instructors teach in Georgia's public and private schools and colleges and possess a love of learning and an interest in young people. Leslie Mims Tichich, a former Governor's Honors Program art teacher, expresses her reactions to teaching the gifted students: "Try it! This was the heart of my teaching philosophy. My goal for these young people was to help them broaden their horizons. The sessions represented the most challenging teaching situation I've ever experienced," she said.

Another instructor, Phil Bates, has similar feelings, "It's the best teaching experience I have ever had. Working closely for eight to 10 hours each day, we were able to move rapidly during the program."

Teachers like these help create a learning environment of mutual trust and respect. They possess unique talents and abilities to help students discover and move toward attainment of their maxium potentials. This special environment is nourished by teachers who love to teach and students who desire to learn.

Two staff members appear on their assigned campuses—North Georgia College, Dahlonega, or Valdosta State College, Valdosta. During the preplanning days, the teachers revise and refine the course outline developed in early spring. The visual art program offers students opportunities, materials, and experiences not generally explored in depth during the academic school year. The art program focuses upon removing the barriers to effective visual communication rather than creating new barriers. It helps students see that there is more to art than drawing a still life. Each teacher opens studios, unpacks boxes of supplies, and plans for the arrival of 15 to 20 students. With preliminary preparations completed, an enthusiastic teacher receives the "go" signal.

The students spend each morning in the art classes with instruction by the teacher. They come from all areas of Georgia—from Rabun Gap to Tybee Beach. Concentrating on questions and problems proposed in art studies involves each in media exploration, compositional problems, art criticism, idea development, art philosophy, and history. Although their backgrounds vary, the students have similar expectations. They want to broaden their understanding of art. Each student wants new ideas, whether in concept or in approach.

Careful planning and creative teaching is required to challenge each student. Teachers, as individual as the activities they plan, meet the challenge head-on, armed with a personally designed, flexible course outline. Interchanges between students and teachers evolve with care and emotion through a variety of activities.

For example, one art teacher planned the program around the theme, "The Renowned Artist As an Exemplary Model For The Student." A study of how, when, where, and why artists create artworks furthered the students'

understanding of the artistic process. All students had some knowledge of line, texture, and balance, but continued to explore these components of visual form through design activities, discussions, films, slides, tapes, and readings. Such statements as "Art is primarily a nonverbal mode of thinking and expression . . ." or ". . . like other communication systems, the visual arts have a syntax and form that is comprised of basic elements and principles . . ." were presented for discussion.

Other sessions center around work in the artist's studio. Three basic steps encountered by the artist in creating art are experienced. First, the student discovers an idea and establishes a direction. Second, the idea is given form. third, the artistic merits of the work are evaluated. Media understanding develops through activities in drawing, painting, photography, printmaking, film animation, and sculpture. To augment this experience, professional artists make presentations concerning methods they use to create art. Films and recorded interviews of renowned artists are available. Field trips are scheduled to acquire visual notations and ideas for studio interpretations.

The combination of activities provided the students gives insights into artists' thinking and ways of working. For many students, these experiences give them a real taste of self-discipline; for some it was the time they discovered other students who think as quickly, use media with as much facility, and know much more than they. One example of a course outline is presented here, but during each summer, many special situations and opportunities for growth emerge.

Another important aspect of the Governor's Honors Program is scheduled during the afternoon. Titled interest areas, these 2/ hour classes provide opportunity for students to develop an appreciation for excellence in academic areas other than the art major to which they have identified commitment. This appreciation includes the concepts that fields of knowledge are interrelated, that learners are interdependent and that there are other learners with talent and ability comparable to their own. These gifted art students are often multitalented and are eager to select an interest area which stimulates their inquisitiveness. David, a visual art major, discovered that the concept of beauty is expressed through another arts form: dance. Sarah, a communications major, discovered how to visually record an idea after enrolling in the interest area "Marking From the Right Mode" offered by the art staff. Gifted and talented students take great pleasure in intellectual activity and are attracted to aesthetic dimensions. The interest areas provide these features. Unencumbered by classic evaluation pressures, grades, and peer competition, the art students are able to work in independent study, changing strategies as necessary while retaining a defined goal. During the summer program of 1977, Glenn Purcell changed his strategy and discovered his future career. As assistant designer with Anne Klein and Company of New York, Glenn reflects on how the Governor's Honors Program influenced his decision to study fashion design and textile design at the Fashion Institute of New York.

"It was my first big break! It was a major step in preparing me to strive for bigger ideas, bigger things. The artwork I created during the program and after I returned home helped me to earn a scholarship to the Fashion Institute. My portfolio was filled with batiks, fabrics painted with dyes, soft sculpture on silk and drawings. My exposure to the excitement and possibility of designing on fabrics began during that summer.

I attended with the other students a performance of the Atlanta African Dance Group. Afterwards, members of the dance group visited the art class to discuss

the African culture with emphasis on native dress. The fabric design unit which followed the discussion exposed me to an area of art that I had not previously experienced. The art teacher, Barbara Crouse, was a fiber artist who introduced me to the ideas for fabric designs and to techniques I could use to produce those ideas. The friendship of the other art students, an inspiring teacher and exposure to a new art form gave me the courage to pursue my choice of an art career.''

Since leaving the Governor's Honors Program, Glenn has studied at the Winchester School of Art in England, visited the major textile centers of Italy, worked as a freelance designer for Bill Blass, Ltd., and designed the prints used in Donna Karan's and Louis Dell'Olio's Collections for spring, 1983. Glenn's sister, Christy, has joined him in New York as a freelance designer for Christian Dior, Anne Klein and Company, and Regina Porter. Christy Purcell attended the Governor's Honors Program the following year, 1978, and was a finalist in the School Arts Symposium, an annual statewide student exhibition of highest quality. As art students, both exemplified numerous characteristics attributed to the gifted and talented.

Not all of the students select a career as a fashion designer. Norris Ivie, a student at the Atlanta College of Art, recently became the youngest artist selected to exhibit paintings in the binannual Artists-in-Georgia show, juried this year by Holly Solomon, New York gallery owner. A 1979 Governor's Honors art student, Norris aptly phrases his viewpoint of the program.

"It kept me from becoming a doctor. I had made the decision to fit into a financially secure career. The art teacher gave me courage and intensity. Being with other excited and enthusiastic art students stimulated me to push myself. Emphasis on experimentation, not products, allowed me to explore ideas and media. Now I become very serious and headstrong if I don't work. The program just heightened my curiosity about a lot of people, places and things. It encouraged me to explore everything.''

The Governor's Honors Program's hallmark has long been the profound effect it has had upon all those who participate. Such programs exist in other states, but Georgia's was among the first and it remains unique, both in its approach and its delivery. It is indeed an honors program and it brings credit to the legislatures which fund it (more than $600,000), to the governors who sponsor it, and to the Georgia Department of Education whose staff works behind the scenes to make all the pieces fall into place at the right time. Each year's program seems stronger than the last. Each year the students leave knowing they've been somewhere very fine indeed.

---

*Ruth Gassett is Consultant, Arts and Humanities, for the Georgia Department of Education.*

# The Pennsylvania Governor's School for the Arts

## • CLYDE M. MCGEARY and ARTHUR GATTY •

During the late 1960's, staff of the Pennsylvania Department of Education, following elements of a comprehensive plan in arts education, worked to create a school for talented and gifted students in the arts. The school began as an experimental program and lasted for several years. It was conducted at the George School in Bucks County and later at Westminster College in Western Pennsylvania. Out of this early experimentation and review of similar programs, namely Interlochen and the North Carolina Governor's School, Pennsylvania's program was created and funded through a cooperative arrangement with the State's 29 intermediate units and Special Education funds.

For the past ten years, the State of Pennsylvania has been offering its artistically talented high school students in visual art, music, dance, theatre, photography, and writing, a full scholarship opportunity to receive intensive training in their chosen art fields. Funds for this program are drawn from an appropriation that is a part of the Department of Education's budget.

In addition to a basic curriculum, featuring the arts, the program includes career education and leadership training. Students spend five weeks in residence during late summer on the campus of Bucknell University. Bucknell is located in the quaint and beautiful town of Lewisburg. The location is central in the state about a one-half hour drive east over Nittany Mountain from State College, home of Penn State. Bucknell was chosen as the site for the Governor's School because of its central location. Further, it offers a picturesque campus that is well equipped for the arts. It has few other summer programs, thus allowing for a full range of attention and campus space for eager young arts students.

Because a healthy arts community is essential to the quality of life and attractive to cultural and business development, the Governor's School was created to help educate young people who have the potential to build a stronger society with their talents. Sponsored by the Pennsylvania Department of Education and the state's 29 intermediate units, the Governor's School selects approximately 225 sophomores and juniors, including the handicapped, to work in a total arts environment where they can take artistic risks refining skills and developing their leadership abilities.

Most of the program's 2,500 + alumni have said that the Governor's School stands out clearly as one of the most important experiences in their lives. Apparently, they feel that they received special guidance and support at a time when they might otherwise have drifted from their artistic inclinations. To build upon a thought of Stanislavki: the five weeks at the Governor's

School helps students explore the art in themselves as well as their futures in the arts.

### Selection of Students

Students wishing to apply for a Governor's School scholarship must be residents of Pennsylvania. That is, their parents or guardians must be Pennsylvania taxpayers. Further, they must be sophomores or juniors about to advance to their junior or senior years. There are no age restrictions other than those associated with such grade levels.

Applications for the Governor's School are provided through school guidance offices and arts teachers. Posters and flyers in addition to a brochure detailing all aspects of the School, encourage students to apply. Students prepare portfolios and audition tapes depending upon the arts areas that interest them. Many students apply in several arts areas. The first level of applicant screening is made through reviews conducted at intermediate units—clusters of school districts usually organized to serve several counties. There are 29 intermediate units (IUs) in Pennsylvania. This initial step in the selec-

tion process takes place about mid-school year, February. Following Governor's School guidelines, intermediate units select the best of their applications and submit a maximum of 10 in each art area to the Governor's School office. After each intermediate unit selection, all application materials—tapes, photos, portfolios, etc.—are returned to the students. At a later date, generally within a few weeks, each student is notified by the Governor's School office as to his or her standing.

The semi-finalists are then invited to personal auditions/interviews held in March or April at locations (usually about six sites) throughout the state. Various additional support instruments, developed by PGSA staff are administered at audition centers. Information gained from standardized tests, at this point, is only used to support general selection guidelines. Further, during the audition/interview sessions the director of the Governor's School conducts an orientation for all candidates and their parents about the goals of PGSA. Questions are answered, and details are made clear on expectations from the point of view of students, parents, and administration of the school. Final judging of student applicants is conducted by Governor's School department chairpersons and specialists in each field. Students are notified of their final standing by the end of April or early May. The final selection process gives great emphasis to extraordinary student interests and talent. Every effort is made to maintain the process as one of high integrity. Fairness and balance associated with a quality program and state-wide interests are important, too.

About 60 to 70 finalist students are selected for the visual arts portion of the total program which, in turn, serves about 225 to 250. Portfolios are reviewed and the selection judges examine art work examples as well as statements and extemporaneous products prepared by students. In the final analysis, subjective consideration by the judges is applied with concern for

each student's creative ability, originality, technical proficiency, and desire for continued education in the arts.

## Leadership

Governor's School students return to their home communities and schools across Pennsylvania every year contributing their talents to sharing and promoting the arts. The inspiration and enthusiasm with which they do this is their own; they learn how to implement through special leadership training offered at the Governor's School. Leadership is an important aspect of the school program because it is the way that expands general student capabilities and helps to multiply the effects of a strong arts education effort within the state. Students wise to the ways of establishing and maintaining a strong arts program justify the taxpayer's investment in the school. Legislators and governmental leaders who have received letters and visits from PGSA students speak glowingly of the positive ways that the school serves so many young people and their families. Such letters and visits are sincere but not left to chance.

Realizing that leadership is both an activity and a quality, workshops cover methods of how to organize, communicate, and be an effective leader as well as offer suggestions regarding what can be accomplished. Ed Lilley, a long time member of the Governor's School theatre faculty and the director, lead sessions on "brainstorming" and working with emotionally and physically handicapped children. Some of the projects that characterize the ways in which PSGA students have been able to reach thousands of others every year are:

- Organizing fund raisers.
- Teaching arts classes at community centers.
- Conducting poetry workshops in senior citizen centers.
- Teaching year book staffs how to take and develop photographs.
- Teaching dance classes at a school for the deaf.
- Encouraging local business persons to participate in arts festivals and donate store window spaces for exhibitions.
- Organizing and directing Black History assemblies.
- Photographing local landmarks for historical documentation.
- Organizing a music library for a high school.
- Teaching mini-courses in sign language.
- Conducting Saturday morning mime workshops at an elementary school.
- Choreography for school theatre and musical performances.
- Speaking to service clubs.

## Career Education

In recent years, the Governor's School has advanced its career component in answer to growing pressure exerted on students by schools and families to pursue traditionally secure, non-arts careers. For both the 1981 and 1982 sessions, the program received special grants from the Pennsylvania Department of Education to fund career education activities that could not otherwise be met under the general operating budget.

96

The focus of these activities is a series of visiting guest artists/lecturers who possess information about career options in the arts and arts related fields. Speakers have included theatrical agents, actors, artists, members of dance companies, directors of art galleries, professional photographers, and principals of major symphony orchestras, to name a few. Such presentations take the form of lectures, demonstrations, performances, or discussions before the entire student body and in master classes within particular art areas. Kevin Bacon, who recently starred in the motion picture "Diner," visited the PGSA campus and discussed the course of his career. Kevin is a Governor's School graduate. As the School continues through the years, many graduates who have scored successes are anxious to return and share their experiences and advice.

In addition to reviewing personal experiences, the guest artists/lecturers also recommend approaches to various careers ranging from educational planning to such important, yet often overlooked, details as how to write a resume, how to prepare for an audition or gather materials for a portfolio. Students

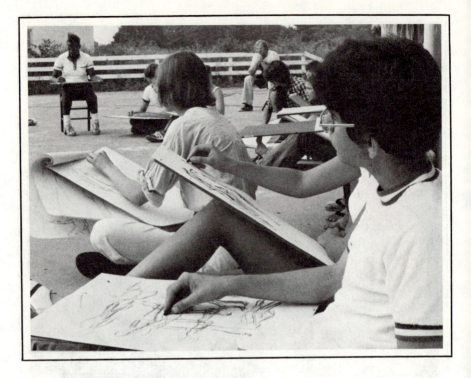

have acknowledged that the visitors help them assess their personal career needs and the appropriateness of different opportunities in respect to these needs. For instance, dancers have learned that there are alternatives to performing and teaching—they can be dance historians, dance critics, or dance therapists if they are so inclined. Student artists with interests in computer sciences are thrilled to learn about work in computer graphics. All in all, the great emphasis at the Governor's School is to help students understand the many and diverse options for career possibilities that are open to them. The school does not overemphasize the need for students to direct themselves toward an arts career.

In conjunction with the career education component, the Governor's School helps its students begin planning for the future by holding a college fair each summer. Representatives of institutions of higher education in Pennsylvania offering arts curricula are invited to bring literature about their respective programs and set up a place where they will have the opportunity to meet some of the state's most artistically talented students and prospective applicants.

### Students With Special Needs
Since its inception, the Pennsylvania Governor's School for the Arts has been committed to accommodating talented handicapped students for whom the arts can offer meaningful personal and career goals. Not only does their class

work enable them to acquire the basic skills and inspiration to work and support themselves independently in the future, but the residential aspect of the program provides exposure to the daily demands of living and socializing with non-handicapped peers.

The special needs students have returned unanticipated dimensions to the Governor's School over the years. Their involvement is yet another way in which the program can offer students what is often their first interaction with people of different sociological, economic, and geographic backgrounds. More importantly, though, the non-handicapped students gain a rare perspective on communications, movement experiences unique to visually, hearing, or physically impaired classmates.

The influence of the handicapped component has been so strong that the program now includes sign language instruction as an elective course in addition to special workshops on brailling. These are held in response to the requests of students. These features have inspired many students to return to their home schools and communities and do volunteer work in facilities for individuals with special needs, and some have planned careers that will combine the arts in therapeutic work.

**The Visual Arts Curriculum**

As a process oriented program, PGSA encourages students to discover that the arts are bound by commonalities—perception and the phenomenon of sound, time, light, space, texture, and movement. Fundamental elements and principles of each art area are explored and studied within frameworks of perception, communication, and symbolic/creative expression. In doing so, students are involved with perceiving, responding, understanding, creating, evaluating, and developings skills. This working/learning design, described in Pennsylvania Department of Education publications such as the "Arts Process," serves as the basis for studied experiences at the school.

The visual art curriculum includes planned features such as:

*Ceramics*—Developing skills in throwing, constructing, decorating, glazing and firing pottery and sculpture. Firing includes techniques in bisque, raku, reduction and oxidation firing.

*Drawing*—Developing ability through practice with pencil charcoal, conte and ink to create the illusion of space. To apply the principles of composition and design in drawing from still life arrangements, landscapes, nature and human figures.

*Jewelry*—Developing craft skills in metal, acquiring functional knowledge of tools and equipment, improving skills in the process of sawing, filing, soldering, modeling, casting, fabrication, polishing and exhibiting.

*Painting*—Developing skills in the exploration of form and surface textures. Knowledge of color through the study of hue, value, and intensity is emphasized. Further, the application of this information is explored through various styles and subjects that are shared to sharpen critical skills. Individual expression is emphasized.

*Printmaking*—Developing craftsmanship through etching, wood block, and other print media. Understanding of inks and papers, the use of presses, the control

of light and dark, color, and composition. Silk screen, intaglio, and lithograph are studied, too.

*Sculpture*—Exploring three dimensional composition emphasizing use of space and form. This includes "sketching" in clay, wax, or cardboard. Modeling and firing clay together with carving wood, forging, cutting, and welding metal.

*Fibers and Weaving*—Understanding qualities of various fibers with emphasis upon their incorporation into woven form. Craftsmanship is emphasized through weaving and other textile processes. Students are encouraged to learn the use of various looms as well as develop techniques in batik and stitchery.

## Typical Day

Though it is not unusual to find students rising at 6:00 a.m to work on a sonata, a sculpture, painting, or, a dramatic monolog, a typical day at the Governor's School begins as the Bucknell chimes mark 8:00 a.m. At that time, as many as 100 different learning activities in the major arts areas are launched, ranging from formal group instruction to individual activity. Effort is intense. Individual research and creativity are encouraged and guided. Instruction is a balance of artistic production and solid measures of student skill building and understanding.

After a lunch break, students return to classes, this time in elective arts areas. To foster an awareness of the challenges and processes experienced by artists in different areas and to broaden creative encounters, students must opt for studies selected from an art area other than their major field for the entire afternoon. Not only have these original goals of the component been realized, but many alumni have reported that because of their elective pursuits at PGSA, they have combined a second art with their major in college studies and careers. In some instances, students have taken up their elective as their major higher education career goal. It is not uncommon for PGSA students to demonstrate high degrees of talent in several art areas.

The Governor's School day continues after dinner. Students return to their major art classes at 6:15 p.m., and at 9:15 p.m. a special program or lecture is usually scheduled. The later activity is flexible. During the first week of the program faculty members might take the stage, giving the students a chance to see their instructors in the role of artists, while later, guest artists give presentations, or student performances might be featured.

Topical workshops are interspersed during each week of the school. Subjects range from leadership training or career education to sessions designed to explore the relationships of the various arts and to technology and society in general.

Unquestionably, the Governor's School for the Arts has established itself as a tradition and fundamental part of Pennsylvania's commitment to quality education.

---

*Clyde M. McGeary is Chief, Division of Quality Goals, Bureau of Curriculum and Instruction, Pennsylvania Department of Education.*

*Arthur Gatty is Director, The Pennsylvania Governor's School for the Arts.*

# The South Carolina Governor's School for the Arts

• PHILLIP C. DUNN and THOMAS A. HATFIELD •

Nineteen eighty-two has been a special year for those of us involved in the arts and art education in South Carolina. First, it marked the final phase-in of our program to place certified art teachers in the state's elementary schools, and second, it marked the encore performance of our Governor's School for the Arts (GSA).

> The need for this special school was recognized and a plan to begin a Governor's School for the Arts was formulated and presented to Governor Richard W. Riley. Recognizing the potential in providing such a program, . . . the governor's office took steps to help implement the program and to provide partial funding for it (Store-Pahlitzsch et. al., 1981, p. 1).

The school, established in 1981, is a five-week summer residential honor's program for artistically gifted and talented students. Designed for a limited number of rising high school juniors and seniors, the school provides intensive study as well as artistic enrichment experiences. The Governor's School for the Arts is administered by the School District of Greenville County, under the leadership of Dr. J. Floyd Hall, Superintendent. The director of the program is Ms. Virginia Uldrick.

A task force was chosen to make recommendations to the director of the program. Mr. Arthur Magill, retired business executive and patron of the arts, agreed to serve as chairman of this committee. His support and expertise have been invaluable in providing the energy and leadership necessary to initiate program activities and generate funding for the school.

This special arts program has been implemented for the gifted and talented students in South Carolina in collaboration with the State Department of Education, the South Carolina Arts Commission, the Greenville County Museum School of Art, Furman University, and with input from arts educators, artists, consultants, arts patrons, administrators, and interested individuals from all across the state.

Since the program involves such a unique collaboration among several agencies and institutions, it is conducted on several sites around the Greenville area. The GSA arts students are housed in dormitories on the campus of Furman University. Theatre, music, and creative writing students attend instructional sessions in the various theatre and music facilities at Furman. Visual arts students, however, attend classes at the Greenville County Musuem School of Art.

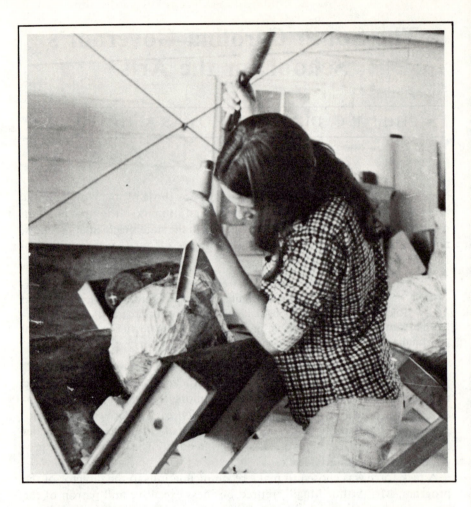

## Program Organization

The South Carolina Governor's School for the Arts currently consists of classes and workshops in four major areas: creative writing, theatre, music, and the visual arts. The program combines highly sophisticated instruction by experts in these fields with a series of life and career planning sessions to promote a balanced approach to the study and practice of the arts. First hand experiences, intensive investigation, individual research, performance and exhibition are all melded together during the five-week period of study.

The daily schedule of class work and activities for these talented young artists is very demanding. Usually students are involved in classroom work from 8:45 a.m. to 5:00 p.m. with everyone returning for evening classes for special activities from 7:00 p.m. to 10:00 p.m. Weekends are used for special events, activities, performances, exhibitions, and guest presentations.

The visual arts component of the Governor's School for the Arts includes special instruction in the following areas: drawing, painting, sculpture,

ceramics, textiles, jewelry making, and two-dimensional design. The faculty who instruct in these areas are all exhibiting artists who have also shown consistent dedication to the teaching of art.

The facilities for instruction in the visual arts in the Governor's School are superior. The Greenville County Museum School of Art, which is housed in Greenville County Art Museum, is a bright, well-conceived art studio facility that boasts large studio spaces, modern equipment, and close proximity to a major American collection of paintings by Andrew Wyeth. The atmosphere in this facility is almost contagious for the artist who is seeking to build and develop new skills and sensitivities, and these young artists are no exception.

Sharon Whitley Campbell, Director of the Museum School of Art, sums up the prevailing educational thrust of the visual arts program by stating:

> Just as bones and muscles atrophy by disuse, talents and special abilities must be recognized, utilized, stimulated, developed, and fine-tuned, or they fade and are gone. The situation of the artist in today's world is not an easy one. Talent is a gift, but will and determination are essential for success. We hope to provide our visual arts students with experiences which will help to polish their skills and with opportunities for artistic discovery (Storie-Pahlitzsch et. al., 1981, p. 17).

One unique aspect of the organizational structure of the Governor's School is the GSA Intern Program. Many gifted and talented programs tend to alienate classroom teachers when they invite specialists from the field to do the actual instruction in the program. Classroom teachers are often subconsciously made to feel like second class citizens simply because they have taken the time and considerable effort to become trained in the art of teaching. The South Carolina Governor's School for the Arts recognizes the vital part that classroom art teachers play in the process of identifying, instructing, and nurturing the gifted in art, and is making a concerted effort to involve classroom arts teachers through its Intern Program.

The Intern Program allows classroom art teachers to not only have direct input into the GSA program, but also to provide opportunities to conduct first hand research into dealing with gifted and talented students in a specialized setting that emphasizes the importance of the arts.

Sixteen arts teachers from across South Carolina are currently involved in the Intern Program. Each of them is given the opportunity to earn up to six hours of graduate credit from Furman University for their efforts with the arts students.

Nineteen eighty-two marked the initial year of the GSA Internship Program.

> The Internship Program was designed to act as a vehicle for: study of the nature of the gifted/talented student; study of the Enrichment Triad Model; producing prototypes that will be disseminated throughout South Carolina to aid in the teaching of the gifted/talented; providing assistance in the development of screening procedures for the GSA; and to foster the advancement of the arts in local areas through Internship Projects (Goodman-Willetts, 1982).

## Student Selection

Students who take part in the Governor's School for the Arts are recruited from all parts of South Carolina. These gifted and talented individuals share a desire to explore various artistic topics and media and to stretch their abilities in ways that are not readily available during the regular school year.

Eligibility requirements for attending the Governor's School for the Arts are stringent. Prospective students must be rising high school juniors or seniors who are attending public or non-public schools, legal residents of South Carolina, identified by their teachers as artistically talented, highly motivated, and high achieving, and who have not previously attended the Governor's School for the Arts.

High schools throughout the state are urged to advertise and promote the opportunity that the Governor's School presents. Each school is encouraged to select a screening committee and a liaison person to assure the broadest possible participation in the identification of potential students for the school.

Nominations are made by school principals or headmasters on the basis of specific criteria that are outlined in application materials provided by the Governor's School. The general application requires that recommendations be secured from two teachers, the school principal, and the local liaison person. In addition, personal information, parental permission, and other general testimony regarding application are required to complete the application process. Specific application requirements are slightly different for students, dependent upon which creative area they apply to for acceptance.

Visual arts applicants must complete the general application forms and provide the selection committee with a portfolio consisting of work from any visual arts area. Each portfolio may, however, contain only six works. Two of the six works must be drawings; one of these required drawings must be a self-portrait, and the other must be a drawing of an open umbrella. Flat works that are larger than 20" × 24" and all three-dimensional work must be submitted in slide form with a maximum of twenty slides including slides which show detail views of art works.

Final selections for applicants are made by a panel of artists. This panel judges the portfolios, evaluates recommendations from the students' teachers and principals, and, beginning in 1983, will evaluate applicants who attend visual arts auditions where the students will be asked to produce art and to do some visual problem solving as an additional component of the application process. The judges choose a limited number of students as first selections and several others as alternates. Alternate choices are included in the school when and if openings in the school occur.

## Funding

Initially, funding for the Governor's School for the Arts came from several areas. Seed money, in the form of substantial grants came from the Office of the Governor of South Carolina, the School District of Greenville County, and the South Carolina Arts Commission. Donations from local corporations, the small business community, private individuals, and the $150.00

tuition fee charged to each student who attends the five-week school made up the remainder of the operating budget.

Proceeds from tuition currently provide funds to cover only ten percent of the total per-student expenses necessary to operate this program. Therefore, fundraising remains a major concern and responsibility of the director of the school. At this point in time, efforts are being made to raise additional funds from private endowments, local chambers of commerce, civic groups, and various local educational organizations. The South Carolina Art Education Association adds its support by sponsoring a tuition scholarship to a deserving student. Hopefully, other state arts and professional educational associations will share in the financial sustenance of the school.

**Ramifications for Public School Art and Gifted Programs**
Gifted and talented programs in South Carolina schools have increased dramatically since 1975. Categorical funding for these programs through the State Department of Education has increased from $300,000 in 1975 to $1,662,000 for 1982. Currently, eighty-five of South Carolina's ninety-two local school districts offer programs for the gifted and talented.

Rural states like South Carolina, however, pose some unique problems for gifted and talented programs at the local level.

> When you find the gifted child in a rural or low density populated area he or she may be (1) isolated from intellectual stimulation and from learning resources; (2) unsophisticated—uninformed, lacking in social and learning skills; and (3) deprived culturally and educationally (Plowman, 1980, p. 73).

Programs like the Governor's School for the Arts are a viable attempt to begin to address the problem of providing special education programs for youth in geographic areas that are characterized by open space and few people. Not only does the Governor's School parallel and reinforce efforts that are being undertaken during the regular school year, but it also brings these gifted students together in one of South Carolina's great cultural centers. For many of these students, simply being with other young people who have the same intellectual capacities and interests may provide the first experience where they have not been made to feel different or strange. Being housed and educated in one of our three major urban areas also has the potential for opening up new vistas for many of these students as they experience urban living and the resources that are available there.

The major shortfall in the relationship between the Governor's School for the Arts and other gifted and talented programs throughout the state concerns the limited range in age that the Governor's School addresses. By only serving rising high school juniors and seniors, the remainder of the state's gifted and talented students are virtually excluded. But this problem is not the fault of the Governor's School for the Arts. In fact, the Governor's School, hopefully, will function as a prototype program that will generate increased interest and public support for expanding statewide gifted and talented programs in the arts for students at all levels.

One of the major benefits of the relationship between the Governor's School for the Arts and the public and private schools of South Carolina is the Internship Program for master arts teachers. This program offers a unique link between functioning artists and functioning arts teachers as partners in educating the gifted. Ultimately, the Internship Program should yield a cadre of arts teachers in South Carolina that are better trained in recognizing and dealing with the gifted and talented in art and provide the Governor's School with an increasingly sophisticated student population.

There is no doubt that the Governor's School for the Arts is a showcase program. The level of funding that has gone into bringing this program to fruition is large when compared to the level of funding that South Carolina generally expends on educating its entire student population. This speaks well for the commitment of the governor and others in his office for attempting to address educational issues in new and creative ways.

The time, money, and effort that have been and are being spent on this program are absolutely vital to the expansion of the arts in our state. The Governor's School for the Arts is raising the level of public awareness and appreciation for the arts as it seeks to maximize educational incomes for a segment of our young people who have been previously ignored. Arts educators all over the state can look to this program for support of their own efforts in many ways. It is hoped that the Governor's School can expect that same level of support from arts teachers as it continues to evolve and expand its efforts.

---

*Dr. Phillip C. Dunn is an Associate Professor of Art, and Director of Graduate Studies in Art, at the University of South Carolina in Columbia.*

*Dr. Thomas A. Hatfield is State Art Consultant for the South Carolina State Department of Education, Columbia.*

**References**

D. Goodman-Willetts, "The Governor's School for the Arts Internship Program," Unpublished paper presented at the South Carolina Art Education Association Fall Conference, 1982, p. 2.

P. Plowman, "What Can be Done for the Rural Gifted and Talented Children and Youth," in, *Idea for Urban/Rural Gifted/Talented: Case Histories and Program Plans*, Barbara Johnson, ed., National/State Leadership Training Institute on the Gifted and Talented, Los Angeles, 1980, pp. 73-87.

L. Stories-Pahlitzsch, B.L. Sinclair, and D. Trakass, eds., *The Governor's School for the Arts*, School District of Greenville County, Greenville, S.C., 1981, p. 17.

# ARTS/The Program and the Process for Recognition of the Gifted and Talented in the Arts

## • CHARLES M. DORN •

The Arts Recognition and Talent Search Project is a national effort to provide scholarships, cash awards, and educational experiences for some of America's most gifted and talented secondary age students in art, music, dance, theatre, and creative writing. In addition to recognizing these students, the program also is giving much needed recognition to the arts programs and the teachers which contributed to their development. While this effort by *ARTS* is only a beginning, in time, and with the support of the nation's arts educators, *ARTS* may well become *the* single most valuable program for recognizing excellence in the arts in the nation's schools.

**Historical Development**
*ARTS* as a program is now concluding its first full year of activities under the leadership of the National Foundation for Advancement in the Arts of Miami, Florida. The program was initially developed and sponsored by Educational Testing Service with financial support from the U.S. Department of Education, the National Art Endowment, and several private foundations. During the 1979-80 school year, two separate national programs were developed, one called the National Arts Awards Program and the other called the Presidential Scholars in the Arts Program. These two programs form the conceptual base of *ARTS* as it exists today.

The Presidential Scholars in the Arts Program developed from the concerns of a succession of U.S. presidents, starting with Lyndon B. Johnson, to find ways in which high school students in the arts might receive the same kind of recognition afforded Presidential Scholars in math, science, English, etc. For nearly twenty years, efforts to identify quality high school arts performance generated considerable discussion and argument but produced no positive results. In June 1978, however, some real progress began with a conference of the National Forum on the Arts and the Gifted funded by the U.S. Office of Education and continued with the development of five position papers prepared by the four arts education organizations at the invitation of the U.S.O.E. Commissioner's task force on the Gifted and Talented.

During the fall of 1979, with funds from U.S.O.E. and with major support monies from the Educational Testing Service, five arts panels were formed to develop criteria for evaluating performance in the five arts areas. While the effort had a bit of a head start in visual arts, based on its experience

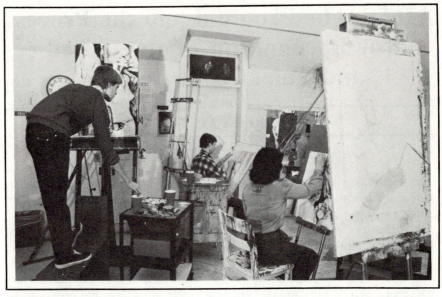

*Painting studio.*

with Studio A.P., the panels in music, dance, theater, and creative writing had to develop their guidelines from scratch.

In spring 1980, ETS officially launched the Scholars in the Arts program, using the guidelines developed in the five arts areas. In this first effort 5,000 high school art candidates applied, and more than 100 finalists were finally recommended to the Commission on Presidential Scholars for further consideration as Presidential Scholars. At the same time, The National Art Awards Program was developed along similar lines except with a much broader aim. While operationally both use the same common evaluative process, N.A.A. sought to expand the kinds of recognition, the financial support offered, and the numbers of talented secondary age students included.

N.A.A. was originally conceived by former ETS President, William Turnbull and his staff, and initally was supported by both the National Endowment for the Arts and ETS. In the summer of 1978, a conference was organized at ETS to develop, as its proposal states, "a mechanism for the avowed purpose of achieving recognition and cultivation of talent and literacy in the arts." This effort continued in 1979-80 with the setting up of *NAA* guidelines by five panels similar to ones used for the Scholars in the Arts program. By the time this effort concluded, more than 40 national associations in the arts and education participated in the planning and developing of the program, with the governing boards of 28 associations formally endorsing it.

In the 1980 N.A.A. program, 3,580 candidates participated, with 343 being singled out for recognition. From the 151 semi-finalists selected, 82 were named finalists, and 21 became Presidential Scholars. The names of all candidates were submitted and recommended for over $325,000 in scholarships

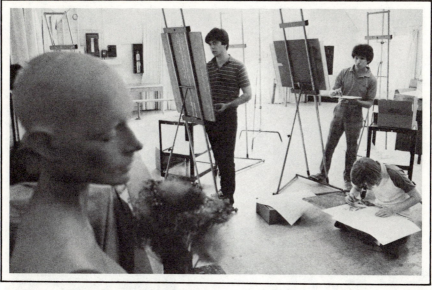

*Students working from a still-life.*

and awards, with the 21 N.A.A. Presidential Scholars candidates receiving $1,000 cash awards and all finalists receiving $500.

ETS, in the fall of 1981, while pleased that N.A.A. and the Presidential Scholars Program had been launched, also realized that it could no longer continue to make major commitments of ETS funds to the program. Fortunately for the program, however, Mr. and Mrs. Ted Arison, residents of Miami, Florida, decided to support the program with a $5,000,000,000 grant for a three-year period. Arison, artistically frustrated as a youngster in his home country of Israel, immigrated to the U.S. to become successful in a vacation cruise business in Miami, Florida. Having both a concern for young people in the arts and in repaying the city of Miami for his good economic fortune, Arison married the two interests by establishing what now is the National Foundation for Advancement in the Arts of Miami, Florida.

The Foundation, which was established in 1981, took as its basic role to act as a catalyst to bring together individuals and organizations which shared common commitment to the next generation of artists. Although NFAA saw its immediate financial resources as adequate for current programs, the foundation felt more could be accomplished through partnerships and cooperative actions with public and private entities. The NFAA in addition to *ARTS*, supports programs for students more advanced in their studies; these include workshops, internships, and apprenticeship programs, and information and counselling services.

"ARTS '82" which was the first *ARTS* adjudication supported by the Foundation offered a number of important advantages for all participants and especially for those in the visual arts and creative writing. One advan-

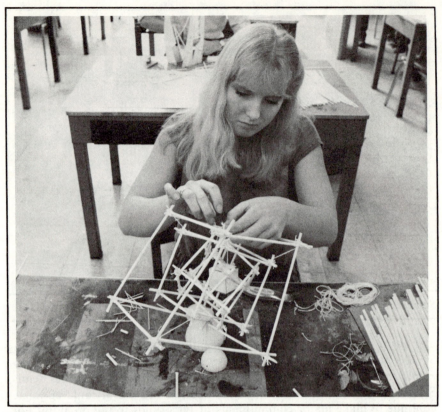

*Tammy Rude works on three-dimensional design.*

tage was that visual artists and writers were able to travel to a central location for final adjudication of their work. As to the advantages offered to all finalists, these included larger cash awards and an all expense paid trip to Miami, Florida. In ARTS '82 the foundation distributed nearly $400,000 in cash awards and made available over $730,000 in scholarships for winners.

**Eligibility Requirements for the Program**
To be eligible to participate in *ARTS*, students, if in high school, must be seniors. If they have dropped out of high school, they must be studying privately or must be involved in an organized arts activity (for example, a community arts program) and must be 17 or 18 years old as of December 1, in the year they apply. They also may not be enrolled in full-time postsecondary education—that is, education after completion of high school—except those accelerated students in their first year of college who are completing requirements for a high school diploma in the 1982-83 academic year. If they reside in the U.S., they must be United States citizens or express their intention to become citizens. If living outside the United States, they must be the sons or daughters of United States citizens.

110

**Applications and Portfolios**

All applicants must pay a $15.00 fee for each art form they wish to be considered in. These fees must be received by October 1 in order to receive application materials. If the student decides later to withdraw, $7.50 of each fee will be refunded. A limited number of fee waivers are available for applicants who cannot afford the registration fee.

**Visual Arts Entry Specifications**

The categories of visual arts in which entries will be accepted are as follows: ceramics, costume design, drawing, film, graphic design, jewelry making, painting, photography, prints, sculpture, textile and fiber design, theater set design, video, and mixed media or other. Participants may submit portfolios made up of any combination of the above categories. They may concentrate in one category of the visual arts, but if so, they will also be required to show some evidence of breadth by submitting in at least one other category. Submissions in all categories except video, film, and photography must be in slide form.

**Visual Arts Portfolio Content and Specifications**

Applicants must include no fewer than 10 and no more than 20 examples of different art work in slide form. In any case, a maximum of 20 slides may be submitted, including any multiple views of works. Submissions of photographs should include 10 to 20 examples, none of which may be larger than 8 × 10 inches. Any submission involving videotapes, video cassettes, and films should not exceed five minutes in length.

**The 1981-82 Program**

*Early Adjudication*

The first round of judging of the 1982 visual arts entrants occurred in December 1981 at Educational Testing Service in Princeton, New Jersey. Nine judges independently viewed slides, photographs, films, and videotapes from over 1,000 applicants. The procedure and the philosophy of the adjudication process is basically the same as the one used in the adjudication of portfolios for the Advanced Placement Program in Studio Art. All the judges in ARTS '82 were experienced A.P. Studio readers.

Jurors in *ARTS*, like their counterparts in Advanced Placement, use a criterion referenced approach which compares the student's performance to what might be expected from students completing a freshman foundation class at the college level. The process assumes that qualified, experienced art judges can reach agreement as to what generally constitutes beginning college-level achievement in art. The jurors, who include teachers in high school as well as college, represent a broad range of art teaching experience, institutional commitment, and demographic influence. Their first task in the judging process is to establish common criteria and levels of qualitative agreement on the rating of the works submitted.

111

The reliability of ratings among the judges is reached through review sessions conducted prior to and during evaluation. During these sessions, individual jurors independently apply scores on a scale of one to four to a random sample of slide sets to arrive at a general level of agreement on the scores given the sample portfolios. This procedure provides assurance that all the judges are looking for the same characteristics in the work and that, within reason, they are assigning the same value to works of similar qualitative levels.

The intensity and frequency of the juror's review sessions depend on the difficulty of the work to be judged. In no instance is total unanimity of opinion sought. What is required is a general direction or tendency of judges' rankings to agree. Additional review sessions with individual judges, or with all of them, are held only when there is a pronounced tendency of one or more judges to award conflicting scores to the same work. More often than not, juror fatigue and failure to clarify the quality to be judged in the product are the cause of widely divergent ratings of the same product. Generally jurors can agree on the aspect to be scored and the level of quality to be assessed.

The number of jurors scoring a given slide portfolio vary as ratings proceed. All portfolios are initially scored by three judges on a scale of one to four. As in the A.P. Studio portfolio review, the judges look for the personal expressive content of the work and the appropriateness of the student's choice and execution of the medium. Judges particularly value works that emphasize unique solutions and avoid tricks or obvious artistic mannerism. The major focus of the *ARTS* Adjudication is to identify performances which are characterized by creativity, imaginativeness, technical proficiency, and which reveal a consistent body of work.

In assessing the individual quality of the student's slide portfolio, the judges tend to give higher scores to works that reveal a personal style of execution and a content initiated by the student, rather than works that appear to be projects assigned by an art teacher. When they review a number of works which are similar in pictorial content and manner of execution, the judges tend to be less sure about the quality of the work submitted even though the work may provide evidence of a high degree of skill. It is, therefore, usually advisable for the student to select his or her own original work (that which is most expressive of his or her own personal style) and to avoid selecting works that, regardless of their technical excellence, tend to reflect a teacher's direction.

In the ETS December adjudication, successful applicants are viewed as possibly falling in one of three groups: finalists, semi-finalists, or talented young artists. Finalists are those who are adjudged to be talented young artists, whose work or performance is characterized by creativity, imaginativeness, technical proficiency, and consistency in the body of work presented: models at this age for outstanding accomplishment in their chosen art form. *Semi-finalists* are considered to be talented young artists, whose work or performance exhibits many of the same characteristics as finalists, but to a lesser degree—particularly with regard to the degree of consistency in the body of

*Paul Whiting at work in the studio.*

work presented. Finally, *promising young artists* are considered to be developing young artists with above-average abilities, whose work or performance, though less accomplished than that of finalists or semi-finalists, is deserving of encouragement and worthy of recognition.

In the ARTS '82 Princeton adjudication, 150 applicants, 30 in each arts category, were selected by the panels to appear for interviews, auditions, and other activities in Miami, Florida, in early January. The applicants who were invited to come to Miami were notified in December and travel arrangements were arranged by E.T.S. and *ARTS*.

At the Miami final adjudication, the thirty visual arts students spent three days participating in a program which was structured both to provide studio learning experiences and to bring about information sharing among the participants. In the studio activities students were asked to complete three half-day problems. Each was given a drawing problem involving a still-life arrangement which included pieces of a store window, bicycle and machinery parts, and many textiles of complex color and texture. Another studio problem assigned was to create a drawing or painting based on an Irish whimsical folktale. The third problem was to construct a three-dimensional sculpture using materials from a kit that included styrofoam balls, string, drinking straws, white cardboard, some cutting tools, but no glue.

During the time that the studio projects were underway, each of the students was also invited to a 15 minute interview with the jurors. For the interviews, students were told prior to coming to Miami to bring four works the judges

113

had seen in their original slide portfolio and four new works. Students were asked in the interviews to talk about themselves, their work, and their plans and hopes for the future. At the close of the interviews a final exhibit was organized, and the judges rated both the three studio projects and the interview. The final ranking of participants in Miami was based on the total score the students received from these four activities.

The students also were honored as artists at the exhibition of their slide portfolios at the University of Miami's Lowe Museum where they met, among others, sculptor Duane Hanson. Other activities included a Miami tour and a visit to the studios of artist Eugene Massin. One of the most welcomed, though not planned for, activities occurred at the first evening, when the students congregated in motel rooms to see each other's portfolios.

## ARTS '83

Participants invited to this year's Miami event will participate in a much fuller week of activities, spending more time in studio activity, in workshops with experienced artists, and in the social and cultural life of the city. All studio problems used in the 1983 adjudication process will be different from the ones used in the 1981-82 program.

As to the future of *ARTS* and the probable impact it will have on the lives of secondary arts students, this will depend on both the continued financial viability of the program and on how the program is administered. As to the financial future, that is, beyond 1983-84, this depends primarily on the ability of the Arisons, and the foundation staff, to attract new financial resources to support the program. What is quite certain now is that the Arisons alone cannot support the foundation at current levels indefinitely.

As to whether the present *ARTS* program concept will be continued in the future, this too will depend a good deal on how the foundation leadership sees its responsibility for carrying out the concepts developed during the formative years of *ARTS* at ETS. At the present time the foundation has rather diverse and, as yet, perhaps not fully developed ideas as to how it might best support the talented young artists in this country. Perhaps its biggest challenge will be to resist the temptation to give priority to supporting university and art school graduates over secondary students and their school programs. For the present, however, *ARTS* will continue to be offered in its present form. To attract students to participate in the program this year over 400,000 arts prospectus were mailed in the month of May to all U.S. secondary schools. While deadlines for completed applications for 1982-83 program closed November 1, 1982, high school juniors can now plan to enter for the 1983-84 school year. Those students and teachers interested in learning more about *ARTS* should write: *ARTS*, P.O. Box 2876, Princeton, New Jersey.

*Charles M. Dorn is Professor of Art at Purdue University, West Lafayette, Indiana.*

## • SECTION THREE •

# Commentary

# Serving the Needs of the Gifted Through the Visual Arts

• CATHERINE A. FRITZ •

Today's demands on gifted students include creative solutions to all areas of human endeavor. If these students are to become leaders in developing new ideas, methods, and materials, there must be special provisions for their total development.

How these gifted students feel, react, interpret, and visualize, profoundly influences their ability to be crucial thinkers, problems solvers, and risk takers. In order to develop these traits, the students need an open atmosphere. The environment must allow for divergence and yet provide for in-depth problem solving and concept formation.

The area where the art educator is of prime importance in the development of gifted students is in their professional expertise in developing and nurturing the creative process. Art teachers are particularly sensitive and knowledgeable in their understanding of the different levels and stages of the creative process. They know the correct timing, exposure, and experiences that are necessary to attain a high level of the student's creativity. The expressive, creative teacher will provide a comfortable atmosphere for students. Once students feel free to express themselves, time, patience, freedom, and space will allow for maximum growth. The art teacher, an intuitive educator, realizes that these special students must grow naturally through the stages of the creative process—that of exposure, incubation, illumination, and execution.

Programs that exemplify how art teaching may help to develop in the gifted student different perceptions and understandings of the arts will be described in this segment. The two programs describe how arts teachers can create unique learning situations for gifted students using resources outside the school. The first program, jointly sponsored by Overland High School in the Cherry Creek School District, Colorado, and the Denver Art Museum, exemplifies this idea. High school students were able to attend special workshops presented by a well-known professional in their particular field of study. The workshops were offered to the students during hours when the museum was closed to the general public. Students participated in two-hour seminars based on art, music, poetry, and dance as they related to different cultural and contemporary art exhibits in the museum.

The first workshop focused on the essence of sound, presented by Gerry Granelli, a music professor from the Naropa Institute. Gerry used the visiting contemporary art gallery which was exhibiting Rauchenberg's paintings.

116

Gerry led twenty students into sound interpretations of the paintings. After he demonstrated a few interpretations, all students eagerly clapped, stamped, hummed, and chanted their interpretations to the painting in this gallery. The second workshop focused on Oriental art, which wsa presented by a Colorado University English professor, Peter Michaelson, who introduced Oriental music and progressive jazz in the Oriental art gallery. After his presentation, students chose their particular art piece to write a successful interpretive statement in the stillness of an Oriental setting. Don Coen, painter, college art instructor, and recipient of the Governor's Award in Painting, presented his views of being a contemporary painter, at the third museum workshop. The final presentation was focused on movement and dance. Darlene Handler, a professional dancer, led the students in imaginative movements based on individual interpetations, in the exhibit of the museum's permanent collection of contemporary art.

The art instructor who was responsible for this program had worked with the Denver Art Museum on other programs and had fully explained this gifted program's philosophy. The permission to use the museum without the interruption of people provided a unique opportunity for these gifted students to explore various contemporary and traditional art forms. The quietness of the institute instilled a serious attitude of appreciation for the contemporary art and that of older cultures. The students who signed up for the program were exceptional students of various backgrounds. Some art students were among this group, but many had not been exposed to in-depth study of an art form.

A similar experience was provided to fourth grade gifted students at Belmar Elementary in Jefferson County. They were involved with an in-depth investigation into African art. Many students were inspired to do further investigative writings, and five students pursued their interest the following year by taking the Jefferson County's Washington, D.C., and New York art tour with this same instructor. They enjoyed this trip, which involved attending plays, concerts, contemporary dances, and daily visits to many art museums. The students were able to recognize Matisse, de Kooning, Kline, Gottlieb, and other major artists' works from one museum to another. They set their own high goals to incorporate this knowledge into new games that challenged their wit and intellectual capacity. The high school teachers were amazed at the the intellectual maturity, enthusiasm, and interest of the students.

A second program for gifted and talented students was the Grand Lake, the Jefferson County, Colorado, School's Summer Art Workshop, which is now in its sixth year. This workshop provided students with the opportunity to observe, work, and discuss with professional artists on a daily basis so that students would learn as practicing artists. This program focused on conceptual development through the process of inquiry, creative and productive thinking, aesthetic expression, and problem solving. The students learned art techniques and process as they created works of art which later

were exhibited in an art show.

Certified art teachers were responsible for the development and implementation of the art courses offered. Each art teacher was also a practicing and exhibiting artist who presented his/her work and philosophy to the students.

Each of the five sessions—sculpture, tapestry, jewelry, acrylic painting, and watercolor, offered the students the opportunity to pursue, in depth, fine art techniques, critical thinking, and an art philosophy to satisfy their personal artistic needs development. The unique setting of working daily and in-depth on an art project, of talking to their peers with the same concerns and problems, of having gifted and talented high school assistants, and of having the uninterrupted attention of professionals for an entire week offered a qualitative differentiated program.

This workshop instilled appreciation in other art forms by providing an evening summer-stock theatre production, a mime workshop, a dance workshop, and a musical performance. The evenings included artists' demonstrations, talks on contemporary art, and information on how to organize a portfolio. The end result of this one-week art workshop provided an understanding of the true role of a professional artist as well as strengthening and broadening the unique talents of gifted students.

These two programs illustrate that art teachers possess the attributes and training necessary to provide unique programs for gifted students in order for them to attain their highest level of being. The art teacher can reflect an attitude and create an environment so that the student will have the opportunity to develop his/her creative and intellectual skills.

A second major task that art programs can accomplish with gifted students is enabling students to understand the great ideas which are transmitted through the world's cultures. As gifted students learn to view art as the expression of themselves, their own culture, and their surroundings, they develop a better perception of the society in which they live. They come to see that artists throughout history have revealed their inner selves through their art expressions. Gifted students thus discover the wealth of thought which has been expressed through the visual arts across the centuries.

As students learn how earlier civilizations cherished their history and how this information was passed on through generations by stories and pictures, they begin to understand the importance of the arts as devices for maintaining culture.

The attempt to develop cultural understanding through the study of the visual arts is particularly effective as a means of investigating primitive cultures. Insights as to the way in which people used visual symbols to express deep religious beliefs, create ceremonies, and establish strong family structures is part of instruction. As the students discover how visual phenomena affected the lives of earlier cultures, they become more aware of the possible conseqences of new visual ideas which permeate today's society. As they solve problems and take risks in the creative process, they develop a problem-solving ability that will transfer into any field they enter.

A program which provides these kinds of learnings was developed with

118

fifth and sixth grade students at Belmar Elementary in Jefferson County, Colorado. The students were given the opportunity to investigate and gather information to complement their social studies unit on the study of Eskimos. Each student chose his or her own particular area of investigation. There was time allowed each day to work with the art teacher to discuss findings and to explore possible ways to further their problem. As this group of students worked, they became very excited about responsibilities, and they asked if they could do a formal Eskimo presentation to the school and their parents. Permission was given, along with the additional request of a Denver Eskimo curator to join this group as an advisor and counselor. The students were able to visit Peter Natan's Eskimo Gallery and to have long talks with him in his studio. They visited the extensive Crane Collection at the Denver Natural History Museum and the Eskimo Exhibit at the Denver Art Museum. The Jefferson County Arts in Education team paid for materials for the experimentation in stone sculpture.

The result of this activity was an Eskimo Art Guide that was written and printed for all teachers and students. The Guide presents a comprehensive study of the Eskimo people. It is to be used by classroom teachers, art teachers, or gifted and talented students of any level. Each section can be used separately, or the complete unit can be used as an in-depth study of Eskimo art and culture. It is designed to complement the sixth grade social studies unit, *Man and His Culture*. To understand the Eskimo culture, all aspects of the people were analyzed. The Introduction of Eskimo Art presents

*"Pot of Gold at the End of the Rainbow,"* ceramic sculpture by Laren Franke, age 11.

an understanding of the Eskimo as an individual. The information on Eskimo migration, outside influences, and religion gives an overview of Eskimo history and conveys how these factors affected their culture. The design section explains the Eskimo's use of the formal elements of design, which will aid the students as they work with printmaking, sculpture, scrimshaw, textiles, jewelry, and basketry techniques. Each of these forms is presented as a separate unit which describes the cultural background as well as the medium, subject matter, technique, and design to be used. In order to provide alternatives for students and teachers, complete instructions for a variety of arts projects are included in each section. The gifted and talented section explains how to use the guide effectively with gifted and talented students.

The students expressed satisfaction and excitement as they worked with professionals as this guide was developed. Their art work was chosen to be part of the extensive slide collection that complements this guide. The gifted students were not only able to experience a truly differentiated program, but they felt a sense of contributing to a product which benefited many students and educators.

Since giftedness is extended beyond those abilities clearly reflected in tests of intelligence, achievement, and academic aptitude, it becomes necessary to put less emphasis on these precise instruments and more emphasis on the qualified guidance from intuitive art educators. Gifted students' outstanding potentialities can be recognized by actual performance. Hence these students require differentiated educational programs and/or services in order to realize their own potential and their contribution to society. If gifted students in art are provided with an opportunity to develop their creative potentials and to explore and expand their talents in a unique environment, they will not only become this nation's most precious resources but they will become the dynamic challengers and conquerors of world problems. As gifted students focus on the process of inquiry, creative and productive thinking, aesthetic expression, and problem-solving with direction from sensitive art educators, they will learn how to appreciate quality life experiences and how to work with their fellow peers in solving critical problems. This will assure the people of this century that these gifted students will continually generate ideas and solutions which contribute to the on-going legacy of man's highest achievements.

---

*Catherine A. Fritz is co-chairman of art, Cherry Creek Schools, Aurora, Colorado.*

# What Happens After
# the Gifted Program?

• JIMMY S. MAINE and ROBERT D. CLEMENTS •

Academically gifted high school students are usually counseled away from art classes, by high school counselors who tell them to take instead academic subjects which will purportedly help them more in their future education and careers. In opposition to this, our project reports the remarkable success of a community-resource-oriented art program for the academically gifted. It reports how their art experiences became the major thrust of both their future education and their careers. How sad that gifted students usually are discouraged from art careers. How wonderful that these eight gifted students herein described had the opportunity to explore the fulfillment possible through art, and, as a result, chose to pursue art careers.

Community-resource-oriented programs have several distinct advantages for the gifted student. Among these are: facilitating the students' access to individualized learning opportunities, changing the learning environment, promoting learning beyond regularly prescribed curriculum, using curriculum planned for and by the student, being involved in experiences which promote understanding of the self, and exploring possibilities for careers.

Other positive factors in utilizing community-resource people are: the use of an increased number of experts, classtime saved for school personnel to work with the average or slow learner, and the school's involvement and support of community lay people.

Confronted with a group of ten highly motivated, high school level, academically gifted and artistically talented students, we found the regular classroom environment left much to be desired. The gifted students' diversified talents, interests, and abilities had to be challenged during the same sixty minutes as their fellow classmates, some of average intelligence and talents and others lower than average. Meeting their special needs was our problem.

With the assistance of the teachers of the gifted program and the school's administrators, a community-resource-oriented program for art was developed. With the commitment of the students, often at first reluctantly, the art program was undertaken and implemented. The community became the classroom, and the community-resource people became new sources of art knowledge and new art experiences.

When designing educational programs for the gifted and talented student, one should consider three major changes: the content of curricula, the method of presentation, and the learning environment. By incorporating these changes, students identified as gifted can be provided for in accordance with

121

*Terry is Assistant Art Director with the University of Georgia's Agricultural Communications, and is completing his university degree in art.*

their particular educational needs and potentialities. Opportunities to pursue special in-depth interests and to develop a variety of abilities can be available without the constraints of schedule programming, time limitations, or confinement to a single classroom.

No one can predict or measure the long-range influences these encounters will bring, for either the student, the artists, or the crafts people. Of ten students who began the program, eight completed it. Seven went on to ma-

jor in art in college, and six completed art degrees. The following eight core studies can only suggest the power of such art programs for the gifted.

## The Case Studies

### Terry

Terry had an interest in art before coming to high school. He was enthusiastic about being in the community-resource-oriented art program. Terry had met a local potter, Sonny Bartlett, who was in the process of building a studio/shop; an apprenticeship was agreed upon. Terry agreed to work one hour each day during school. More time would have been permitted, but he worked an eight-hour shift in the local textile mill in order to earn money for college tuition.

In the pottery shop, Terry was not only involved in creating art objects, but was also instrumental in building the shop itself. As time progressed, Terry was encouraged to submit a portfolio of his art works and to compete for possible scholarships. He later received two scholarships. He chose to take the full two-year scholarship offered by Reinhardt College in North Georgia. During his two years there, Terry held workshops on Saturday for general education students not in the regular art program.

Afterward, by working in the textile mills again for two years, Terry saved enough money to continue in college. Terry was accepted in the University of Georgia Graphic Arts program. Now, six years after the high school program, Terry, a senior at the University and working as an assistant art director with Agricultural Communications at the University of Georgia, says:

> As a graphic designer now, I feel the program was very beneficial in my deciding on an art career for myself. The independent study, association with professionals, teachers, and counselors, and working in the community was of special help.

### Doug

An outstanding student in all academic areas, Doug had an interest in architecture and automotive design. In his search for a community mentor, Doug found no automobile designers, but he did find an architect, noted for individualized designs of family dwellings. The architect agreed to accept Doug into his office as an apprentice two days each week for two hours each day. The schedule had to be arranged around Doug's advanced placement classes as the local junior college. Doug's interest in architecture continued after graduation. At the Georgia Institute of Technology, Doug chose for his major the study of architecture.

### Cyrus

Cyrus chose to learn by doing. Portrait painting was his area of interest. He wanted to develop his own technique, but he was also open and willing to accept the constructive criticisms of others. In the hallway of a group of art shops, he set up his easel and painted portraits. The local artists who passed by generously offered their professional advice, and the boy's interest

and abilities grew.

Cyrus came to the attention of the art association members who decided to sponsor him with a grant. The grant was given so he could participate in Saturday workshops at the Atlanta College of Art. After graduation, Cyrus decided to major in art at the Atlanta College of Art. During the summer, he worked at Six Flags over Georgia, as an artist, painting portraits. Soon he worked his way to supervision of the other artists employed there. During the regular college year, Cyrus worked with a variety of Atlanta Printing Companies, gaining valuable experiences. Cyrus has graduated from the Atlanta College of Art and is now a graphic art director in his hometown.

### Dan

Dan's interests were music and comic heroes. His collection of comic books was extensive. His decision to create and mass produce his own cartoon books was an ambitious undertaking for his ability.

Dan visited the local newspaper and printing shops. With some friends, he created and produced a small circulation newspaper. Dan's limited ability was overcome by his enthusiasm and hard work. "Mystery Man" appeared in numerous four-page publications. As his abilities grew, Dan chose as new subjects, Rock music stars, done in high contrast. In a few weeks Dan was able to draw portraits of his friends and capture their likenesses.

After high school, Dan attended the local junior college for awhile, but became distracted by the lure of self-employment in art. He created a one-of-a-kind T-shirt business. Since then, he has undertaken numerous art adventures and is now creating art for himself and his friends.

### Mike

Mike, an energetic, sixteen-year old senior, had been told that his intelligence quotient was higher than most students; therefore, he could see no need in being expected to fulfill normal class requirements. With little effort, Mike was outstanding in math, science, and English. But homework was a source of frustration because it interfered with his band's practice; he had organized a band and needed to practice often. When asked to participate in the community-resource-oriented program, Mike's response was positive, but he insisted that a flexible schedule was imperative.

Mike chose to work with a local painter, Peggy Maine, in her studio. He was free to work during school hours, one hour three times each week or two hours twice each week. He was free to come after school and to bring friends. On several occasions, ten students were in the studio, asking questions and sharing experiences. Under the artist's guidance, Mike enjoyed experimenting with a wide variety of art media and subject matter. Severely critical of his own work, Mike seldom completed a drawing or painting. He would work on parts of a composition, pursue it as far as he wanted, and then move on to something else. Mike and his resource person painted, asked questions, visited other artists' studios, and viewed displays and exhibits. This experience led to Mike's decision to major in art at Auburn.

*Tam'ra received a four-year scholarship and has completed her university degree in art history.*

## Joan, Laura, Tam'ra

Joan, Laura, and Tam'ra were inseparable. They were involved in the same extra-curricular activities and in the same gifted class; their only class schedule difference was that Joan did not take an art class. Hypercritical of her own efforts in creating art works, Joan simply refused. Laura was excited about

any new adventure, and Tam'ra agreed to participate if it did not interfere with her existing obligations. Not wanting to be left out, Joan was willing to negotiate.

An independent study course was created for Joan, Laura, and Tam'ra, to correspond with the art teacher's planning period. This class period was after their gifted class, but lunch hour was in between. Therefore, three hours of school time was available.

The production of art was not the primary emphasis on their pursuits. Interviews with artists and visitations of galleries and collections became a part of their school days. When artists lived too far away from the school or did not have adequate studio space, they were invited to the high school art classroom. There, the three would put together luncheon workshops and invite the other participating students.

When accepting invitations to visit nearby private collections, the three were often pleasantly surprised when the hosts extended invitations to the art teacher and all other class members as well. Having lunch in elegant homes and discussing art collecting while the student body of the high school was lunching in the school cafeteria, left impressive memories.

Tam'ra and Laura encouraged Joan often, and their efforts were rewarded. During the creation of the school play's stage sets, Joan was totally involved in every detail. Selecting the proper furnishings, creating illusions from verbal descriptions, and manipulating tools, paint, and brushes, were done by her without hesitation.

During this period of time, they volunteered to be aides in an elementary school. The fifth grade students' uninhibited use of art materials and their enthusiasm were positive factors which helped Joan gain confidence in her own abilities. Joan was no longer afraid to try.

After graduation Joan worked in a State Department Law Enforcement Office. Today Joan and her husband are business partners.

Laura, after graduation from high school, spent a year as a missionary in a Northern state. There she came in contact with ceramics produced by a religious sect. This contact helped Laura choose to pursue this area in more depth. Her decision to attend the University of Georgia fulfilled her areas of interest in both religion and ceramics. There, in the University's Studies Abroad Art Program in Cortona, Italy, and in its tours of studios and cathedrals, Laura was surrounded by others who shared these same two interests.

Tam'ra received the local Marie Ford Scholarship, a four-year full scholarship to the University of Georgia. Possessing so many capabilities and interests, she found it difficult to choose a major area of study. After being involved with several false starts, she chose art history as her field. She has not completed her Bachelor of Fine Arts degree in art history.

## Considerations in Implementing the Program

The implementation of the community-resource-oriented art program was successful because of its direct approach. All students participating in the

program first selected an area of interest. After making a selection, they searched the community for someone educated or knowledgeable in that area. They would report their findings to the art teacher and coordinator of the gifted who reserved the authority to make final judgements. A decision was then made on each finding after evaluating all circumstances. When students proposed working with artists and crafts people of questionable moral character, or persons without quality training or experience, they would be diplomatically encouraged to look for other possibilities.

We found it to be of utmost importance for the students to report their findings, experimentations, questions, and problems as often as possible. For some students, contact even daily was necessary; for others, one reporting each week was sufficient. With periodic encounters and honest reports from the students, problems can be avoided or dealt with as they arise.

The students had to evaluate their schedules and obligations in order to be realistic about taking on new commitments. For some students, their daily art class was the only period of time available. Others were fortunate enough to be able to combine several class periods. The best arrangement was combining the last period of the school day with hours after school.

The artists and crafts people were soon discovered to be more numerous than we had expected. The local art association was a great source of artists and crafts people. The public school system employed numerous people with art-related training. The junior college in the neighboring town was a storehouse of possible candidates. A local businessman had helped attract many artists and crafts people to the area, many of whom had opened small art shops.

The students were totally responsible for their own depth of involvement. Personalities of the student and the resource person had to be compatible, or termination was immediately agreed upon. Possible exploitation of the student or a misunderstanding of the purpose were factors for which one had to be constantly alert. Distractions, such as frequenting a nearby McDonald's Restaurant, led to curtailment of off-campus privileges.

The art teacher's lunch hour and planning period were used for follow-ups, get-togethers with the students, brief workshops, or meet-the-artist times.

## Conclusion

Our community-resource-oriented art program for gifted high school students was an educational program adaptation to fit the needs of specific students at a specific time. It was influenced by recommendations which appeared in the National Art Education Association position paper, that school art programs should provide experiences in seeing artists produce works of art in their studios, in the classroom, or on film.

Today, most children of all ages are limited in their contact with artists and crafts people. Popular published articles, television, and movies often present stereotypes, biased views, false hopes, or complete inaccuracies about art vocations. Because of the unrealistic views held by many parents, counselors, and educators toward artists and crafts people, children possessing

high intelligence quotient levels are often discouraged in their interests to pursue art experiences careers. They are seldom encouraged to come in contact with or to have artists and crafts people for role models. This segregation of artists and crafts people did not occur in primitive societies. There, children daily witnessed the creation of functional and decorative objects. The artist and craftsman was a real individual, a part of the child's visual and spiritual experiences. These important exposures helped shape their adult philosophies toward art careers and their value to society. Because of this societal integration, children with superior abilities or advanced intellectual capabilities were not constrained in their artistic development by an inaccessability to the creation of art.

Although the artists and crafts people are no longer as visually available as in primitive societies, many artists do willingly accept the role of resource person by opening their studios, workshops, galleries, and homes to individuals and groups. Their availability as resource people can be secured easily by making a few phone calls.

The structured educational systems of today, the administrative problems encountered in providing special transportation, making curricular adjustments, and providing opportunity for independent study can be real obstacles and require flexibility and commitment. Such programs on a large scale would necessitate some increases in financial outlay for hiring qualified personnel to coordinate daily activities. When conducted on an individual basis for eight students, as was our program, the community-resource-oriented program entails no increased expense for the school.

The purposes of programs for the gifted have been to broaden horizens, encourage creativity, emphasize critical thinking skills, and develop leadership skills. But these goals are difficult to accomplish if the student is limited in his environment, drowned in interesting but distracting facts and information, or underchallenged. Many alternatives to traditional education programs and typical environments of the classroom exist, but for these to be beneficial, they must be as individualized as the students. Reintegrating the school with the community eliminates many artificial barriers to the development of gifted students' potential. The power of this program is shown by the fact that seven of these eight gifted students, the kind of students who are usually counseled away from taking art, went on to major in art in college and to pursue it as a career.

---

*Jimmy S. Maine is Art Teacher at Warner-Robbins High School, Warner Robbins, Georgia.*

*Robert D. Clements is Professor of Art at the University of Georgia, Athens, Georgia.*